UNIQUE
HUSTLE

PRAISE FOR *UNIQUE HUSTLE*

"Will's always taken care of me with the best whips in the world. When I was a kid, we used to play a game called Bingo, and when you shouted 'Bingo' that was the car you wanted. Now kids do that with my cars. I give Will full responsibility to do his thing, and he always does a great job."

—LeBron James
Los Angeles Lakers

"Will Castro is an artist. He sees things with a deep vision where others may see nothing."

—Erik McMillan
Former all-pro NFL safety

"Will Castro is my brother. He's all heart, a true friend. He's always there for me and my family."

—Fat Joe
Hip-hop artist and actor

"Will Castro is one of the best people I have met in show business. And the fact that he's also Puerto Rican doesn't hurt. He's one of the most

knowledgeable people in regard to the repair, renovation, and restoration of vehicles. His story is amazing. You have to read this book. I love the guy."

—Geraldo Rivera
Journalist, reporter, author

"Will's craftsmanship is impeccable. For him to take regular cars off the street and add style, luxury, and street flavor...I'm blown away by it."

—Sean "P. Diddy" Combs
Entertainment mogul

UNIQUE
Hustle

My Drive to Be the Best Car Customizer in Hip-Hop and Sports

Will Castro

With Mark Finkelpearl

Mango Publishing

CORAL GABLES

Copyright © 2019 by Will Castro with Mark Finkelpearl

Published by Mango Publishing Group, a division of Mango Media Inc.

Front and back cover courtesy of Johnny Paul Melendez, Lebron James, and Will Castro; courtesy of Nat Newsome

All other photos courtesy of The Will Castro Archives

Photographers: Jim Bibbee, Troy Parasio, and Steven McMahon

Graffiti art courtesy of Keith (Reme) Rowland

Layout Design: Jermaine Lau

For permission requests, please contact the publisher at:

Mango Publishing Group
2850 Douglas Road, 2nd Floor
Coral Gables, FL 33134 USA
info@mango.bz

For special orders, quantity sales, course adoptions and corporate sales, please email the publisher at sales@mango.bz. For trade and wholesale sales, please contact Ingram Publisher Services at customer.service@ingramcontent.com or +1.800.509.4887.

Unique Hustle: My Drive to Be the Best Car Customizer in Hip Hop and Sports

Library of Congress Cataloging
ISBN:(p) 978-1-63353-889-4 (e) 978-1-63353-890-0

Library of Congress Control Number: 20199932087

BISAC category code: BIO002030—BIOGRAPHY & AUTOBIOGRAPHY / Cultural, Ethnic & Regional / Hispanic & Latino

Printed in the United States of America

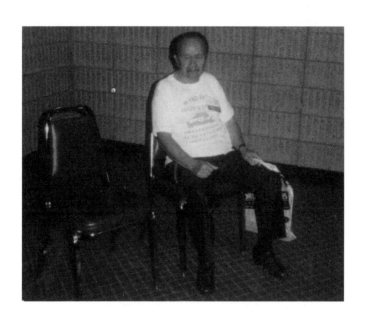

THIS IS DEDICATED TO MY GRANDFATHER BONFACIO.

*HE BELIEVED IN ME, KEPT ME FOCUSED, AND
ENGRAINED IN ME MY WORK ETHIC.*

I LOVE YOU ENDLESS PAPI.

TABLE OF CONTENTS

FOREWORD

This book is amazing. When I was coming up in the game, if you were into cars, flyness, and taking it to the next level and you did not know Will Castro, you were going to hear about him soon; his work speaks very loudly. It inspires me. He's part of hip-hop culture. Just start with all the whips he did with Busta Rhymes. I remember once seeing an eighteen-wheeler filled with Busta's amazing cars, and they were all Will Castro builds. Eventually, Will and I connected through Fat Joe. All the cars that Will built for Joe thrilled me. Will started by putting rims on my Escalade. Then, from there, we upgraded to foreign cars—we started getting into the Rolls-Royce world, the Bentley world, the Phantom world. And I found as we were doing all this together that his customer service was unbelievable. He'll get on an airplane and fly to you just to have a conversation. Will Castro was born to pop up. Whether I have a car to work on or not, he's there with something to represent his brand. Will is hip-hop. And his customers are always satisfied. I don't even want to call them customers. They're more like his family friends. And I know for a fact that if I need Will, he'll come through for me and for his friends. Every time.

Hip-hop people express their success in different ways. For me, I like to project happiness and how blessed I feel to have made it in the game. And sometimes we like to treat ourselves with a beautiful car. And what is more beautiful than a Rolls-Royce touched by Will Castro? What I love in my cars and what Will always gives me is a clean interior. Everything gotta be fly: the paint, the rims, the stereo. Sitting in a clean interior with a white T-shirt and jeans is like putting on a pair of brand-new sneakers straight out of the box. And that's the thing, Will knows our life, and so he knows the presentation we need inside these cars. Sometimes, he gives us too much presentation, and then we have to do a million shows to keep up with what Will is bringing. But he's bringing it. There's nothing we can do to stop him.

DJ KHALED
Miami, Florida

PREFACE

Writing this book wasn't all that easy for me. It brought up a lot of memories I would rather have forgotten. But I decided early on that if I was going to write down my life's story, I had to do it openly and honestly. I had to be willing to look at what I'd done wrong in my life and own it. And it hasn't all been terrible. In fact, so much of it has been so great, I *had* to write a book! Going through my life has brought back to mind phenomenal moments that I'd not thought about in decades, especially of my childhood spent on the streets and in the projects of New York. I hope that if you get anything out of my life's journey so far, it's something about persistence in the face of tough odds. It's about never, ever giving up, even when you're down on the mat and the ref is two slaps into his three count. If you get up and keep fighting, you never know what's around the corner. And just having a chance to *get* around the corner is a blessing from God. Keep going. You won't get anywhere if you don't keep steering down that road. Just make sure you have some nice rims as you roll!

Will Castro

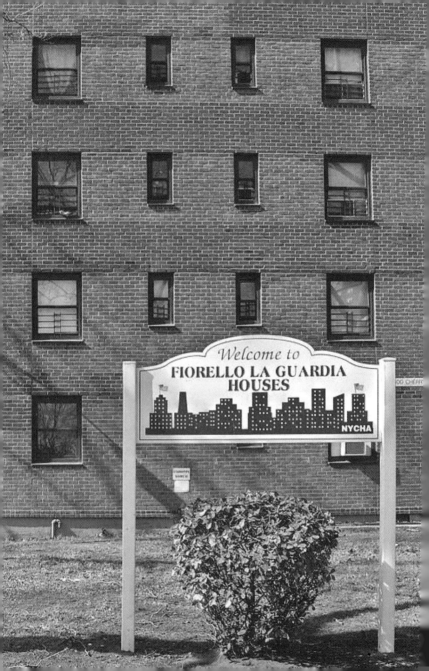

CHAPTER ONE

THE END OF THE BEGINNING

It was a Sunday afternoon, just like any other, when the doorbell rang at my house in 2008. I got up to answer it, walking away from the football game on TV. The second that I opened that door, my life changed forever, and I would experience the darkest times I ever knew. And I had no idea yet. Before that doorbell went off, I was on top of the world. I was living the American dream. I had a house, a wife, and a fabulous daughter named Paige. We were living large. At home, I had a personal chef cooking for us every night. I had a hit TV show on Speed called *Unique Whips* and a new one on Spike TV. I had a star-studded, celebrity client list that wanted me to customize car after car for them. My clients were guys like Busta Rhymes, Erick Sermon, P. Diddy, LeBron James, and Jeff Gordon. I even hung out with Donald Trump at Trump Tower long before he won the presidency. (Trump in my day was a New York businessman a lot of people admired.) I was at the top of my game. I was successful and smart. And now I had to answer the door. When I did, I'd figure out fast how not successful and not smart I really was.

"The second that I opened that door, my life changed forever."

Two federal officers were on the other side, one man and one woman, dressed in dark suits. They had gold badges and guns. Seeing them was like getting hit by a Maybach on a reckless Sunday joyride. I immediately thought to myself, *I got a problem.*

"Do you mind if we talk in the house, Mr. Castro?"

I showed them into my spacious and comfortable home, past the huge saltwater fish tank, past the large-screen TV, through the kitchen, and out to the landscaped backyard with the patio furniture and high-end gas grill. Looking back, I probably should have just walked out the front door, shut it behind me, and talked to them on the porch. But it was too late for that. They were in my house, and they saw all the material things and creature comforts that we had.

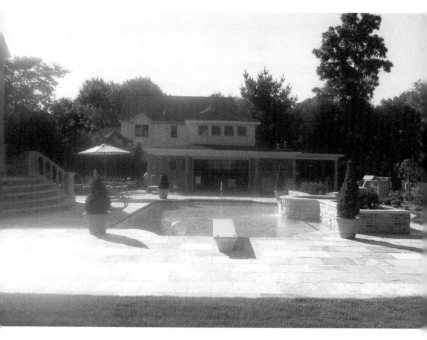

WILL'S LONG ISLAND HOUSE WHICH WAS VISITED BY FEDERAL AGENTS

They wanted to talk about back taxes and the fact that I had not filed a tax return with the IRS in a few years. I've replayed this day in my head a thousand times. They had me there. And why had I not done what every American was supposed to do when they were making the kind of money I was, giving Uncle Sam his fair share? I was naïve, stupid, and dumb. It's that simple.

You gotta understand, I was a kid from the LaGuardia public projects on the Lower East Side of Manhattan growing up in the 1970s and '80s. In my neighborhood, you made a buck, you kept a buck. That's it. Nobody thought about taxes, and everyone used cash. It's no excuse. I had a mom who worked hard every day of her life in a dental practice. I had a step-dad who had a good job with Con-Ed, the electrical company in New York. But when I struck gold with my business, I was thinking the way I learned to on the streets. My money is my money. Or, more importantly, I was not thinking. I had a big business with lots of employees, and I paid them all in cash at the end of the week. They appreciated that, and nobody ever asked me why I did it that way. I never went to business school, but I was a businessman. Nobody ever told me about social security taxes and withholdings. I was about to learn the hard way. The TV show, *Unique Whips*, didn't

help me. The producers made me look like some kind of Tony Montana, an OG. I wasn't. And the show I was doing for Spike TV didn't help either. And the fact is, I wasn't dirty. My business was legitimate. I just wasn't paying all the withholding taxes for my employees on the incoming money, and, instead, I was supporting a lifestyle at home beyond my means.

"I never went to business school, but I was a businessman."

As federal agents sat in my pool house, asking me questions that I really didn't know how to answer, it was suddenly crashing down all around me. Before I knew it, I was going to have my lawyers telling me to choose from three different federal correctional facilities: one in New Jersey, one in Alabama, and one in North Carolina. Prison? It looked very much like I was headed there. But I'm getting ahead of the story. Way ahead.

THE LOWER EAST SIDE

Here's the thing, you've got to have some kind of hustle, some kind of grind, some kind of drive to really survive on the streets of New York. You just have to. If you don't, it will eat you alive. You've got to have grit to make it. Growing up as a kid in 1970s New York City defines me; it was an experience that still reverberates in the man that I am today. I grew up on the Lower East Side, what's known as the LES for short. I lived in the LaGuardia Houses, thirteen public buildings built in the 1950s and made up of nearly eleven hundred apartments. New York at the time was just like what you see in old movies from the period. I don't mean comedies like *Plaza Suite* and *Annie Hall*. I mean films like *Super Fly*, *Mean Streets*, *Shaft*, *Black Gunn*, and *The French Connection* that capture the dirt and the grit and the look and the feel of the city. But it was the people, the characters, that made New York at the time so incredible.

Today, with New York being as expensive as it is, the bohemians, musicians, artists, and dope dealers have moved out. Back then, all the good and all the bad were smashed together. To a large extent, kids like us were on our own, and the city was our backyard and playground. You had to be home for dinner and you had to listen when mom called. But we were free-

range kids. Parents did not helicopter the way they do today, and guys like me and my friends were not attached to cell phones all day and night. We could not be tracked, which made for some serious adventures. We were urban, minority Tom Sawyers and Huckleberry Finns and the East River and New York Bay were our Mississippi. We came in contact with all of the good, the bad, and the ugly. And it formed us as people. It was incredible because it was so multicultural; you were immersed in a world of so many different people, so many walks of life. You had Chinatown. You had Little Italy. The Village. You had Katz's Deli; there was a large Jewish influence from the days of the Ellis Island immigration. By the time the 1950s and '60s rolled around, the LES was filled with Puerto Ricans (like my family) and folks from the Dominican Republic. You had it all.

That's New York. And once you're a New Yorker, you're always going to be a New Yorker. You know you're special. I would never give my childhood up for anything. It just was amazing, living down there at that time. It was beautiful. There were rough areas and some bad people, too. An outsider coming into the Lower East Side would feel a little threatened and scared. However, if you were born and raised there, you

WILL CASTRO ON THE LOWER EAST SIDE, CIRCA 1967

felt like you were untouchable, because you were so comfortable with the surroundings.

In my neighborhood, I went to P.S. 137 and grew up with all sorts of people. There was no racism there. None. We were all from the Lower East Side. We were all minorities. We were from public housing. We were all one, and we all went to the same Boy Scouts, Cub Scouts, PAL football, OLS little league, 10th Street baseball leagues, and 7th Precinct Roadrunners football. (The Roadrunners wore black and gold just like the Pittsburgh Steelers, and that turned us into Steelers fans at a young age just as they were becoming unstoppable Super Bowl champs.)

My father was William Castro, Sr. and my mother is Minerva Capo Castro. They both came from Puerto Rico. My dad was from a tough neighborhood near Old San Juan called Santurce that has the distinction of being the most densely populated neighborhood on the island. My pops influenced me a lot. I always looked up to my dad. He was athletic. Everyone respected him in the neighborhood. My dad was an ambulance driver for a health center, one that still exists to this day in New York. My father was the first person to expose me to a love of cars. He had a hot, red Mustang. It was a '68, short window, fastback, automatic transmission

with a black interior. That car was respected by the neighborhood; everyone knew that was his ride. Besides cars, he got me into the Yankees and took me to ball games on Bat Day.

"My father was the first person to expose me to a love of cars."

My parents got divorced when I was about seven and my brother Bobby was just a baby. They just could not get along. My dad was a playboy, and he liked to have a good time. He was also hot-tempered: one of my main memories of his red Mustang is not a good one. I must have been about seven years old and my parents had just recently split up. My mother was dating a man named Al at the time. Al and I had been out somewhere, and he brought me back home. As we were pulling up to the building, I saw my father's red Mustang parked there and it alarmed me. I said to Al "I think that's my dad's car, you better just drop me off here," but Al told me not to worry about it. As we were walking toward the building, my father approached. He said hello to me and told me to go up to the apartment

to my mom, he and Al were going to talk for a while. Well, my dad ended up beating him up pretty bad; Al went to the hospital. I'll never forget it.

I think the bad aspects of my parents' relationship had an effect on me and my brother down the road, because you try to be a better person, a better father. (I tried to be better in my first marriage with my wife Marilyn and my daughter Paige.) I think that divorce is a bad thing. At the end of the day, it's the children who are most hurt. So my dad and my mom didn't see eye to eye, and he wanted to remarry a woman named Naomi. My mom was hurt by that; I know how much she loved him, and it was hard to see her struggle. She became a single parent. She worked hard doing odd jobs to put food on my and Bobby's plates. Not once did she go on welfare. Her main career was as a dental assistant and later she became a dental supervisor. She was employed by the city of New York and worked for thirty-eight years before she retired and moved to Florida.

My father was still around after the divorce; he lived uptown, in Spanish Harlem. He would pick me up on the weekends. He and Naomi had a steady relationship, and they wound up getting married and having kids

together, my brother Chris and my sisters Nayree and Dawn.

I did not see my dad every day, but there was a man in my life who was hugely important. That's my mom's dad, my *Papi*. His name was Bonfacio Martinez. Papi was a merchant marine, then he worked at the courts on Chambers Street at city hall. He was very into politics and was always dressed to the nines in a suit, a very proud Puerto Rican. At the courthouse, he was a court officer and file clerk, and he took that job super seriously. He lived with us in the projects, and, every year, he took me to Puerto Rico, connecting

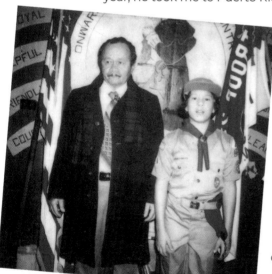

me forever to my ancestral home. Papi was there through thick and thin. In my youth, I also developed a faith in God, and I believe God was there too. I'm not really religious, I don't go to church every

WILL AND HIS PAPI, EARLY 1970s

Sunday. But I do believe that God acts in my life and I pray, a lot. I've needed to!

Through it all, life in the LES was still fun and amazing. My best friend was Kenny Williams, and we were inseparable from grade school through high school. Kenny lived on the second floor, while I lived on the ninth floor at the LaGuardia House. It all began with a fight outside our building. There were bullies all around, and I was a short, small kid. I got bullied a lot, and, because of it, I used to try to duck into the back door of the building to avoid the mess of kids always congregating out front. One time, I was walking in with my mom and said, "Mom, I'll go around back."

She said, "What for?" I told her I didn't mind going to the back door, it was okay. But she soon realized that I was being bullied. And by one kid in particular: Kenny Williams.

Well, my mom decided to call up Kenny's mother, Hattie, and she said, "Hattie, your son is bullying my son. They're going to go outside and fight right now, and this is going to end today."

I said, "Ma, I don't want to fight. I don't want to fight."

She said, "No, your ass is going to go downstairs, and we're going to settle this, once and for all. You're not going to be going through no back of the building."

And sure enough, me and Kenny got into it in the front of the building, and after that we became the best of friends. Inseparable to a point that, years later in adolescence when girlfriends were involved, he would always find a way to mess things up between a girl and me. I write this with a big smile on my face. It's just that we were blood brothers. We played football together, baseball, bike riding, AFX cars. We were so in competition with one another growing up, it was unbelievable. Boxing, karate—you name it, we did it all.

New York City was our backyard. We had those

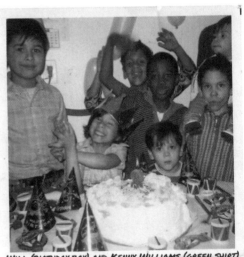

WILL (BIRTHDAY BOY) AND KENNY WILLIAMS (GREEN SHIRT)

1970s bikes with the banana seats (Kenny's was a Schwinn Orange Krate, and I had the Green Schwinn Sweet Pea. He always had the better bike.) and we'd explore the city on the backs of those. At about eleven years old, I remember getting onto FDR Drive at Grand Street and heading north all the way to the Bronx, like 155th Street. We'd see Yankee Stadium there but we never went to ball games. We'd just eat a cheese sandwich or some snack like that and turn around and head home. It was true adventure. We'd head downtown too, all the way to Battery Park. No parents. The city was wide open to us. We saw a lot. Kenny and I watched the Twin Towers being built; I remember the construction everywhere, putting up these incredible works of art. Later, we'd watch them film *King Kong* there, and I have clear memories of the giant gorilla lying on its back in the plaza of the World Trade Center, its huge hand facing palm up and wide open. Kenny and I also did crazy stuff like you hear about kids in the 1970s doing. We'd play Evel Knievel with our bikes; we used to make ramps and light fires inside of cans. We would set up three garbage cans, then hurtle all the way from the end of the block and ride up the ramp and jump them. And then we would add a fourth garbage can. Guys always got hurt, man. Some guys

couldn't jump the ramp! They used to do back-flips and all kinds of crazy stuff. In Manhattan, right there in the projects, they have four-foot chain link fences. So kids would build ramps to jump those. We used to do crazy things, just beating up on our bikes. Crazy shit. We used to swing off flagpole ropes. I mean, just this wild stuff that kids would do.

We also went to work early. There's a famous Broadway play called *Newsies*, and me and Kenny were newsies like that, just 1970s versions. We sold the *New York Post*, and we said one thing, on repeat: "Get your *Post* here! Get your *Post* here!" You had to be aggressive just to make a couple of dollars, but it started one thing in me very young: reading the newspaper. The news of course, but especially the sports section. The

WILL CASTRO RIDING HIS BIKE

back page had the standings, and I started learning about averages and winning percentages and how the Yankees were doing. You know, what's a "clincher," when you clinch the title or when you clinch the division. The Yankees were a big part of our New York culture there. Selling newspapers also showed me the joys of making money and having some bills in your pocket.

"Selling newspapers also showed me the joys of making money and having some bills in your pocket."

This was also a period in time when cars were becoming very important to me, and Kenny had a huge influence on me in that regard. I think if it wasn't for him, I would not have been into cars. That's the truth. It began when we were kids, playing with AFX cars, lying down the track and racing. Later on when we got older, Kenny was the first one of us to get a car: a Plymouth Satellite Sebring. I was in love with that car. Kenny brought me around to his uncle's garage, where

he used to park cars, and then I became a valet parker at Mario's Restaurant. I just did a lot of the things that Kenny used to do. I used to definitely look up to him, like he was a bigger brother, but he was only maybe a year older than me. But this era was later. Once again, I'm getting ahead of the story.

CHAPTER THREE

STRONG ISLAND

When I turned about fourteen years old, my mother decided to move us to Brentwood, Long Island. She felt New York City was changing, so she wanted to get out of the projects and wanted me and my little brother Bobby (seven years younger) to have some space and get into better schools. This was the early 1980s, and things were changing in the city; money was getting more prominent. The rich were taking over. Brentwood is a working-class town in the middle of the island, not far from Islip. Today, there's a big Hispanic community there and lots of African Americans too, also whites. It was a rough transition for me to move, and it took me a couple years to fully adjust. First of all, the kids in school fought a lot; the races did not get along. I was perplexed by this. There was no racism in the projects of the LES. Everybody was a minority. But, in Brentwood, we're supposed to be going to a good school in a good neighborhood, yet it turned out that Brentwood was crazier than New York. The famous TV mini-series, *Roots* was out on television at the time, so young teenagers' sense of racial identity was heightened by that. That show emerged at a time when the whole country shared the same television culture, and it had a huge impact. I said to my mom, "You got to be kidding me, Mom. You told me that this was going to be a cool

environment!" There was truly a divide, and I wasn't about that. For the first time in my life, I really woke to the differences in race and class in New York.

Eventually, one adjusts to a new school with new attitudes, and the way you do so is by earning your stripes. You stand up to racism by not tolerating it. "Around me," I said, "don't do that. You don't treat anyone any differently." And I had to tell people that. I wouldn't tolerate the N-word being used or anything else of a derogatory nature, because that's not what we're about on the Lower East Side. It never was about that.

"For the first time in my life, I really woke to the difference in race and class."

I had to get adjusted and that took a long time. Years, in fact. My friends had to come see me from the city. They met my mom at the Gouverneur Hospital where she worked, and they would drive out with her to Long Island every Friday. They made the transition a little easier for me. I didn't want to live there. I just didn't,

because, you know, living in the city was totally different from living in the suburbs. It really was.

Down in the LES, you could come out of a building, and you'd see a thousand people living in one house. You could see your friends downstairs. We had so many parks you could walk to, bike to. On Long Island, you had to have a car to get anywhere.

I also had the added burden of being a city kid, an outsider not native to the island. That played both ways, because the suburban kids looked to guys like me for their sense of style. We had the flyest kicks, bomber jackets, baseball hats, and fly jeans. We were from the city, and our swagger was different that way. I had the fly wares. I had a burgundy sheepskin with a crown with the 69ers to match. I had suede Pumas. As the fashions came out, that was what it was in the city. It was all about that, because you had to have status if you're coming out of your building. You had to have the right kicks. You had to have the right jeans. You had to have the right bomber. If the goose down was out, you had to have that. And my grandfather made sure I had everything I pretty much wanted. I brought this sense of fashion to Long Island. I also brought music. It was me and kids like me who had the Grandmaster

Flash tapes, the Busy Bee tapes. And the suburban kids wanted all that stuff.

I began playing sports as a young kid in the LES; I took karate with Kenny, little league, things like that. And so when I hit Brentwood, I continued to play football and baseball. This kept my mind off the transition and the fact that Long Island really didn't feel like home at first. That was good. What was bad was that my mom still worked in the city, so I felt badly about her commute and how hard she had to work. She knew this. My mom had to work, while a lot of other parents, including many stay-at-home moms, would drop off their

WILL PLAYS BRUCE LEE, CIRCA 1970

kids at practice and go to games. My mom couldn't do that. My dad couldn't do that. My grandfather couldn't do that. So I didn't have that support. My parents were working. They couldn't come to games. Later on in life when I had my first child, Paige, I tried to do things differently. I went to her track meets and cheerleading competitions. But I understood my mother's position. I understood she had to work.

I would get on her sometimes, saying things like, "Oh, you know, Tippy's mom was at practice."

My mother said, "Lemme break it down to you. I work."

In high school when I was fifteen, I met Marilyn, the woman who would become my first wife and the mother of my first child, Paige. Marilyn showed me what Suburban life was. If it was not for our relationship, I may not have gotten into the car business the way that I did. We met at Bay Shore Roller Rink. Most of us were still too young to drive, so all the parents would drop us off there. Now, for some of you young people reading this, you may not know what a roller rink is, but, in the seventies and eighties, these were places of great entertainment for teenagers. We're talking roller skates, not ice skates. The lights on the roller floor would be low and theatrical, like a disco or a dance

club. Instead of asking a girl to dance, you'd ask her to skate, if the right song was on. Then you'd hold her hand and spin around and around the roller rink. There was a snack bar with bad pizza and an arcade with pinball machines, *Asteroids*, and *Pac-Man*. Disco and early rap were blaring over the sound system. Sugar Hill Gang, Bee Gees, Kool and the Gang. Rock too. Led Zeppelin and The Who. Pink Floyd. "We don't need no education." Teenage hormone heaven. Bay Shore is gone now, long ago ripped apart by a wrecking ball. But back then, it was the center of our teenage social life. Every Friday night, we'd head over there in our school football jerseys, showing team spirit for the game the following day. Wearing your jersey was a way to rep your town: Brentwood, Bay Shore, Islip. One night I was at the roller rink with Kenny Williams, and he skated up to Marilyn and her friends. Kenny broke the ice, so to speak, and we started talking. She went to a nearby high school, not mine in Brentwood. A couple months after first meeting, we were dating.

So slowly, I adjusted. I still had Kenny Williams as my best friend, but I also began meeting other people. One of my best friends who lived across from my mom's house in Brentwood was Joseph Romagnoli (he would later pass away in the 9/11 attack). We rode bikes

together, and he helped me with my bicycle chain to keep the bike in good running shape. Joe was from a working-class Italian family, and we got along really well. Eventually, after several years, Long Island started to grow on me, because I realized there was a new sense of freedom. Back in the city, I was free to roam from uptown to downtown, but, on Long Island, there was space. And that wide-open sense of space brought a new freedom to my life. And now, I had Marilyn in my life. And, of course, when I turned sixteen, I got my driver's license right away. Once again, Kenny Williams had a huge influence on me. He bought a Plymouth Satellite Sebring in a beautiful color: like a sea-foam green. The car had rims on it and a Pioneer stereo system rocking "Dr. Jekyll & Mr. Hyde," which he loved. The sound system was amazing. So Kenny said, "Will, you got to get a car. What's wrong with you?" and he's saying, "How are you going to go anywhere? You got to have a car."

And I said, "Yeah, I got to get me a car." So I talked to my grandfather, and I made up a story. And I said, "Listen, Papi, you know, I'm riding the bike everywhere, and, you know, at night, they can't see me. I don't want to get hit, so I want to buy a car." So Papi helped me out with my

first car. It was a Buick Skylark. It was a black one, really nice. Because I couldn't get the Trans Am!

Kenny was saying things like, "Oh, you got to get the Burt Reynolds car."

I was like, "Yeah, okay. My grandfather ain't buying me that." You know what I mean? So he helped me with my first car, and I got a license. And I used the car to go visit Marilyn. When you're young and you're dating and you've got your girl, you'll do anything at any time to go see her. Well, I left before school at five thirty in the morning once to go hit up her house. I went down this road, hit a patch of black ice right on Brentwood Parkway, I think it was, and skidded right into a tree, wrecking the car. End of story. That was when I first discovered black ice. Marilyn's uncle John had a body shop (I wound up working there later as a detailer), and he fixed the car for me. Soon after, I sold that car and wound up getting a green Pontiac LeMans. That became my main driver for the next several years.

When I turned seventeen, I wound up learning how to valet park cars at Mario's Restaurant. At first, I tried to get a job as a busboy, but I wasn't very good. One day the manager said to me, "The valet is not in today. Can you drive a stick shift?"

I said, "Hell, yeah, I can drive a stick shift." They gave me the job for the night, because the regular guy, Gerard, was out for a couple days. It was a fancy restaurant, and I loved it. I thought *Oh, my God, I got my dream job, parking all these nice cars. I'm getting paid well, loving the tips.* Of course, Gerard eventually came back for his job. He was an older guy too. He was out of high school, while I was still in high school. I had the evening shift after school, and at night is when you make the money.

So Gerard said, "Listen, I usually do the doubles." Then he goes, "I like you. I'm going to give you two days, and you can do the afternoons if you get like a work release from school, if you get out early enough."

So I think I started getting out at—I don't know—eleven thirty or twelve. I had early courses or whatever, and I would work the afternoons and later in the evening, and I fell in love with the job. El Dorados, Rivieras, Ferraris, Jaguars. That's when I got really hooked on cars. I was like, *Wow. These guys got money. They're business guys. They're paying me fifty or a hundred dollars just to park their car.* It was just a great job; I only worked two days a week and wound up being able to buy an engagement ring for Marilyn. You know what I'm saying? So I was doing really well while still in high school.

"That's when I got really hooked on cars."

One day I had a JV baseball double header, and I called in sick to school. In the afternoon, I wound up going to Carvel Ice Cream with Marilyn and running into my baseball coach, and he told me, "I thought you were sick." So he busted me. The following day I went to practice. He had me do ten laps around the park, so this is when I forgot about baseball and football and decided I was going to work and make money. My twenty-dollar allowance wasn't getting me anywhere, and I had to pay for insurance for the car if I wanted to drive.

Now, it was around this time that I first ran headlong into tragedy. Kenny Williams was still my best friend; he made a great effort to stay connected to me when I moved from the city out to Long Island, and our relationship grew more even after I left the Lower East Side. He would come out with my mom every weekend and stay at the house with us. We'd watch Super Bowls. We were both Steelers fans growing up. You know, Franco Harris, Lynn Swann, Mean Joe Green, Terry Bradshaw, L.C. Greenwood, I mean, that whole

Steel Curtain era meant a lot to us. Didn't matter that we were from New York—that was our team together. Me and him were very, very big into football. Kenny was strange in a way; he never liked anybody getting in between us and our friendship, attention-wise. Kenny always wanted attention, always. So he didn't like me having Marilyn in my life. He was one of those guys. Odd. He thought when someone finds a girlfriend, they forget about their best friend.

So one day, he drove to Marilyn's place and brought my ex-girlfriend, Sophie. Marilyn answered the door and turned and said to me, "Oh, Kenny is here with your girlfriend." And she was crying and pissed off that Kenny came with this girl from the city.

And I was like, "What are you doing here? Yo, Kenny, I'm not going anywhere."

He said, "You're messed up. You forget your friends in the city."

I said, "No, I don't. I'm here with Marilyn, and that's it. I'm not going anywhere."

So Kenny got pissed off. He went into my Pontiac LeMans, and, because he hooked up my radio, he disconnected it just to be spiteful. It was very heated that day because Marilyn wouldn't stop crying. Her

father was there, her father who was six foot four and 225 pounds. He lifted me up by my neck with his hand and said, "What the hell is going on here? My daughter is crying," and I remember this because he lifted me completely up off the ground. As I write about it now, it's kind of funny. But it was not back then. I was really small, and this guy was six foot four.

I said, "Can you let me go? Can you let me go?" It was crazy. And I told Kenny, "No, I'm not going," and everything got calmed down. When I left the house, I went to go turn my radio on. The radio didn't play. I was like, *Oh, this guy disconnected my radio.*

So a week went by. Kenny and I did not talk. I was pissed off at him, he was pissed off at me. We didn't talk for that whole week. One night, I was working a shift at Mario's Restaurant doing the valet parking. There was downtime when customers would be eating in the restaurant after I parked their car. So I decided to work on my radio, but I didn't know what I was doing. But I eventually figured it out, and I got the radio to work. I was very proud about that. I was like, *You know what? Ha ha. Kenny, you thought you were going to disconnect my radio. I hooked it up without you. I didn't need you,* because I always needed Kenny for everything—to fix my bicycles, fix my minibike, help me

WILLIE'S SHAPE AND SHINE FLYER 1980s

out with anything. Anything mechanical, I used to call Kenny. So I felt proud that I was able to do this on my own. I thought, *After Mario's, I'm going to take a ride out there with a couple of my friends. I'm going to go to the old building, and I'm going to show Kenny that I hooked up the radio—I hooked up my shit.*

I drove all the way to the LES, pulled up to the building, and walked in the front to the lobby. All I saw was people crying. I was like, "What the fuck is going on? Why is everybody crying?" I told them I was going upstairs to see Kenny, and they couldn't talk. So I went

upstairs, and everyone in the house was crying—his mom, Larry, his brother, his sister, everybody. I said, "Why is everybody crying? What's going on? What's going on? Where's Kenny at?"

And they said, "Well, there was an accident. He's at Beth Israel Hospital. He died."

I said, "What are you talking about? I'm going to show him my radio because I hooked it up." He wound up having an accident that afternoon. It was a wet day in New York, and, obviously, when it rains in New York, everyone has an umbrella in their hand. He was walking with this kid called Jason from the neighborhood. There was a car driving down Delancey Street, and the guy pointed at it with his umbrella. And when he called to him, Kenny shot his head to the left, and the point of the umbrella went through his eyeball and into his brain. He was pronounced dead at the hospital. A freak accident in which my best friend was impaled by an umbrella.

It was a devastating loss, the first time anyone that close to me died. And he was so young, only nineteen or twenty. Kenny was buried at the Evergreens Cemetery in Brooklyn. He's always stayed with me in spirit; I still feel him, and I know that my love for cars and my

pursuit of greatness in the car industry has a lot to do with him. And go Steelers.

Kenny was gone, and I was still working at Mario's, parking all these cars, when I decided to start doing a side detailing business, calling it Willie's Shape and Shine. This was the very first time I was truly in business for myself. My customer base started out with my regulars from Mario's. I would say to them, "Hey, listen. If you want, I do detailing on the side. I would love to pick up your car at your office on my days off, and I would detail it for you." I came up with a flyer and some business cards, and I started doing that on the side. I soon realized that to do this right, I needed specialized equipment.

My mom got me my first Sears pressure washer and

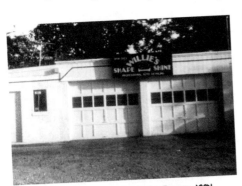

a Craftsman vacuum, and I first worked out of my mother's driveway, cleaning cars.

The business grew. Eventually the driveway was not big enough, and

WILL'S FIRST SHOP ON LONG ISLAND, 1984.
NOTE THE DIRT DRIVEWAY.

I rented a small, one-car garage, maybe six hundred square feet. It wasn't big at all. I was able to get one car in there, and I had a small office toward the back of the building. That was really it. You only could fit a desk in there. I had my polishers, my vacuums, my waxers, my cleaners. The only thing was, there was no driveway. It was dirt. So imagine trying to clean a car in the dirt. I was not too bright on that point!

Marilyn's family was well connected to several worlds on Long Island—construction and automobiles being the two most prominent industries they were immersed in. Marilyn's father, Hugo, was in the general contracting business and was a mason. He did all kinds of concrete and amazing brick buildings, so, as a gift for opening up the business, he did a nice concrete driveway for me. And that was like heaven for me, because now I could work outside and inside. So I could do two cars at the same time.

The shop was in Islip, and I started handing out flyers, and working on friends' and family members' cars. That's how we started. Marilyn's grandfather was a huge Chevy guy. He was very well respected in the automotive business. Mr. Tony Ferraro. And he was retired when I opened up the detail shop. So if I walked into a dealership and said, "Hey, I'm related to Marilyn

and the Ferraros," the sales guys would listen to me and give me an opportunity. I expanded my business that way, detailing cars directly for dealerships, doing more of that work from Babylon to Riverhead. Marilyn's aunt Kathy sold cars. So did her uncle Bobby Torino, who was a big mentor to me. He was a pre-owned sales guy with his own business. Bobby would go to the auction, pick up cars, bring them back to me so I could detail them, and he'd get them ready for sale. He taught me so much. But one day, I detailed a car for Bobby and was confident that I knew everything. But he always had one up on me. He went right to the ash tray, and it wasn't cleaned. Since that day, Bobby gave me a better eye for detail. During this period of my life, I began slowly to expand from simply washing cars to buying and selling them too. Under the wings of a couple important mentors, I was becoming a dealer. To do that, you needed a certificate of authority from the licensing bureau, and I began working toward getting that permit.

Marilyn's uncles, John Ferraro and Bobby Torino, really taught me how to select a pre-owned a car at auction, how to get the car ready for sale, and what customers were going to look for. They both had different methods on how they approached a car when they bought it to

see if the car was in a collision previously. They would teach me how to look at the lines, how to pull the carpet out to see if there was any structural damage, how to see if there were any weld marks that were not supposed to be there, any issues with the motor, engine, transmission.

So they gave me a lot of knowledge. And they referred me a lot of business, cleaning cars from their dealerships. Both of those guys were very big influences on me when I was growing up, and I looked up to them. With their support, I was able to build the detailing business so much that I opened a second location in Patchogue. And, right around this time, I got a dog and named him Boomer after Bengals quarterback, Boomer Esiason. Boomer (the quarterback, not the dog) was from East Islip, Long Island. He went to East Islip High School, and we used to see him around town, so I wanted to name my little dog Boomer after him.

Marilyn's family was having a huge influence on me, but my family was, of course, still front and center in my life, especially my Papi. He would come out regularly from the city, and he and I would plot and plan on how to expand my business. I told him, "Papi, this is what we need to do. For me to take this business to the next level, we've got to go to Vegas, and we've got to go to

the International Carwash Association convention, the ICA. This is what's going to set me apart from all of the other small detail shops on Long Island. I want to be that guy. I know that I'm a small little shop, and us going against all these big car washing detail places... We won't be able to compete with them on money, but I think I'm one of the best out there, and I think I can get better if we can just invest this money to go to Vegas. I can buy from the right manufacturers, get the best knowledge, go to the seminars, listen, and just learn. And I can talk to the best detailers in the world."

So my grandfather, of course, funded it for me and said, "No problem. Let's go." And we went to two ICA events together. We went to one in Atlanta, Georgia, and to one in Vegas. And my grandfather got so tired that he was sitting down, but he was very proud. He'd be like, "Wow, I can't believe that Willie's actually doing this. He wants to really take this to the next level." And that's just me. I've always been driven. I've always wanted to be the best that I can be.

So I got to meet a lot of different people. The funniest thing was, I needed a new pressure washer because my pressure washer broke. I was using a garden hose. And you need pressure to degrease the motors, degrease the wheels, you know, to really get that thing washed

and prepped. So there was this really small unit, 2,000 PSI, and it was the hot little thing that was out in the market. I said, "Papi, I really, really need this, and, if you can loan me the money to get this, I'll pay you back. This is going to help us be a better shop." And he was like, "Let's think about it. I'll see what I can do."

What I didn't know was, he made a deal with the guy and bought the floor model. We picked it up at the end of the show and had to carry that thing back on the plane with us! But that was a big, intricate piece. I was also using nice stainless vacuums. I always wanted to have the best technology, the best products, because then you can charge the fair value for your details.

Because I was detailing serious cars. For example, a customer came in with a nice Maserati. A cool, young guy in the medical field, and he had a lot of cars. He pulled up in this Maserati, and looked at my shop and saw nice equipment and a very clean facility. So he said, "How much? $150? No problem." And we're talking $150 to wash a car in 1985; that's pretty good. So it was a fun time. It really was. In 1985, I was only twenty-one years old and was making upward of one hundred thousand bucks per year just detailing cars. I want all the young people reading this book to listen up! If you commit

yourself to hard work in the car industry, it can bring you a great living. And I was just getting started.

I got all this extra knowledge because I was able to speak to a lot of other detailers around the country who were members of the ICA. They said, "Will, you've got to charge this. This is what people should be paying you." So I learned from other people who were very good to me, and I built relationships with other detailers. This one guy out in Salt Lake City was killing it. I mean, he was making a million dollars on just detailing. I was like, *Wow, you wouldn't think that*. He was scrubbing carpets and polishing cars and making a great living. I mean, this guy looked like a doctor, a car doctor, with a jacket and gloves. He looked like he was ready for surgery, and the guy was charging two hundred dollars to detail your car.

It was the mid-1980s and I was rocking. I had my own successful business and my loving family around me. But I was still hungry; I was still driven, striving for more. I needed to grow. And, as fate would have it, that growth would come not simply by washing more cars, but by customizing them—the ultimate service you could provide to a discerning car customer.

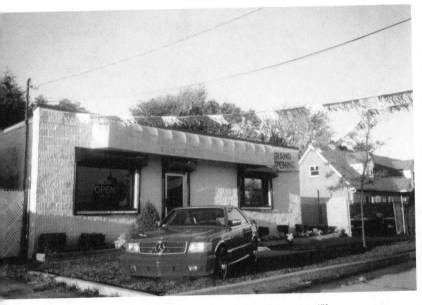

First Unique shop On Suffolk Ave, Brentwood NY

CUSTOMIZING AND THE EXPLOSION OF NEW YORK HIP-HOP

So I was detailing cars in Patchogue, and I had friends of mine who were working for me, Greg and Eli. One day Greg said, "Will, just so you know, I know that you love the detailing, but everyone is getting cars customized down in Harlem. If you go to Harlem on Friday or Saturday night, it's like car show, and it's all our people that come out there with their cars—the BMWs, Nissans, Cadillacs, Benzes. They've got ragtops. They've got body kits. They've got rims. They've got lo-profile tires. They've got gold straps on the back of the trunk for their Cadillac. You've got to come and see it. There're people spending a lot of money, not just on detailing but accessorizing the car."

I said, "Cool. Let's go." So we checked it out and I started thinking, *Wow*, and something just hit me in my head: *If I can learn this business, I think it's going to be a bigger and better business.*

Now, this may be a good moment to explain where car customizing really comes from, its true origins. The fact is, this whole world emerged from urban outlaws, people we used to call back in the LES, "Block Stars." Let me explain this.

Mayor Rudy Giuliani wasn't messing around. When he took over New York City in 1994, the crackdown started

on everything from squeegee guys on the corner wiping down windshields for tips to the X-rated movie palaces lining 42nd Street and 7th Avenue in Times Square. Everything I knew started to disappear. Entire neighborhoods changed, including areas downtown like the Lower East Side. The danger, the grit, the grime, and the character of New York was being scrubbed. And in a very specific way. This washing down of New York affected the car culture and how cars were customized. No longer did car owners want showy glitz and bling. Instead, customizations became understated and subtle. Remember, this isn't the New York where I came of age in the 1980s and very early '90s. First off, back then it was fun. We were young and ready to turn up. New York at the time was still edgy, had its share of hustlers, artists, and gangstas, all scrambling to get recognized and make their mark on the culture. And, from drug dealers in Alphabet City to the gangstas in the projects, every avenue in my neighborhood had what we called "block stars." A block star was a guy everybody knew and whom many feared—for good reason. The local block star had money and power on the street and in the projects, but he didn't have a job. Were the block stars dealing drugs, selling guns, or pimping women? I knew better than to ask those

questions. However they made their money, they were admired figures—everyone in my neighborhood looked up to them, and many young kids saw their way of life as a way out of poverty. One other thing was certain: along with respect and control, these guys had fly clothes, expensive jewelry, beautiful women, and, of course, a banging whip. That means a hot car! A block star had to have an outrageous car to be legit. It's because of these block stars that the car customization industry came into being. Every vehicle had a custom one-off paint job, often a candy-color finish that had a mirror shine to it. Each one had to have hot rims and lo-profile tires. It had to have a custom two-tone interior that was comfortable and roomy and had a super bass sound system. Everybody knew that these cars belonged to the neighborhood's block stars, and nobody would ever do anything to steal them or deface them in any way—unless they were looking to be hurt.

And these gangstas' need to drive eye-popping whips extended to the rest of the artists, urban businessmen, and hustlers in town. By the nineties, record companies were making a big living and hip-hop was exploding. The city was filled with rappers, producers, impresarios, and record executives looking to constantly one-up each other and come out with the next big hit. That

old TV promo goes "I want my MTV," and that television channel definitely helped. People were glued to it, and suddenly if you wanted to make it in music and have an impact on culture, you had to have a hot video. Music was becoming visual. Artists like Run DMC were bringing New York rap into the main stream. Guys like Jam Master Jay were giving power to the DJ. Before Jay, DJs were mostly just in the background, quietly spinning records. First came DJ Kool Herc and then Grandmaster Flash. And when Run DMC exploded, Jay gave DJs an identity in the mainstream for the very first time. This was when artists like KRS1, Big Daddy Kane, LL Cool J, De La Soul, and A Tribe Called Quest were all emerging in New York. The city was lit, we were staying up all night, and custom cars were all over New York. It was a time to be flamboyant. There were no sound ordinances back then, so the stereo systems could vibrate with bass so loud that you could feel the sidewalks vibrating. Windows could be super dark, tinted to the point that they were almost blacked out completely. Just like the block stars, everybody wanted to flash their money, power, and fame, and they wanted to do it with custom cars, spreading their urban lifestyle across New York and out into the rest of the USA. I was

in exactly the right place at the right time with the right set of car skills and the right hustle to be successful.

It would not last forever. Mayor Giuliani's crusade would eventually change the times we lived in, and people started to be harassed if they were rolling in a flamboyantly appointed custom car. There were lots of rap songs written about this by artists like Big Daddy Kane and A Tribe Called Quest. But there were things Giuliani could not eradicate. By the time he came to power, the culture of the block stars was already becoming the wider urban culture in New York and beyond, spurred forward by MTV. And what happened in the music world in the 1980s started happening in sports too. It used to be that ballers made some cash but played for the love of the game. That changed when colossal super stars like Michael Jordan, Reggie Jackson, Lawrence Taylor, and Tony Dorsett began commanding huge salaries. Whether or not they realized it, all these sports stars took a cue from the block stars of the projects in New York. These athletes too wanted hot cars to go with the flashy lifestyle they were able to afford. I was there to serve all these people. So I came away from my first Friday night in Harlem looking at custom cars, and I really believed it was the future for me. In 1988, I saw my very first opportunity

ERICK SERMON, ONE OF WILL'S FIRST CELEBRITY CLIENTS

with a rapper named Erick Sermon. I jumped on it. It all happened because of my little brother, Bobby.

I got a phone call from Bobby and he said, "Will, Erick Sermon goes to school with me. He just signed a recording contract, and he's now with Def Jam and Russell Simmons, and he wants to get this Mercedes-Benz done. He wants a European body kit. Can you do it?"

I said, "You better bring him out here." So now I'm doing some research. I call Klaus, a Lorinser distributor that I knew, and I ordered the kit that Erick wanted. Now the deal with Lorinser is that they originally started many years ago as a garage servicing Mercedes-Benz cars. But they grew into an organization that customized Benz cars too. And by this point in history, you could buy parts and kits to add to your Mercedes-Benz to spice it up. Erick Sermon wanted the Lorinser package: the Lorinser hammers, the fender trim, the ragtop, the stereo system, the grill. The package was about forty thousand dollars. I was laughing then, saying to myself, "Yeah, I'm in the wrong business!" I definitely didn't mind doing forty thousand instead of two hundred for the detail!

ERIK'S MERCEDES BENZ RAGTOP

So I was thinking, of course, I needed to explore this business a little bit more. I went off to Paterson, New Jersey, and learned how to do ragtops. This guy, Dave, showed me; he taught me how to do custom padded ragtops, sunroofs and things like that. In the beginning, I had to do all the work myself. I was an owner-operator. But then I started building my team, getting specialists in those different departments. "All right, you're going to be doing the wheels, and you're going to be doing the ragtops." And I would bring them to school and teach them. "Listen, this is what you need to learn. This is how it's done." And I would explain it to them, step by step. "Listen, I did this, so I know how it's done. This is how you've got to do it. You've got to mask it up, you've got to tape it up, you've got to scuff, put the landau padding down, stuff the landau padding, get the top sewn, put the top down, edge it out, put the chrome on." We ran a real tight ship. And we started becoming the go-to shop for all the rags, all the body kits, and all the rims when it came to Long Island. It was then about 1988–89. Unique was born.

My first real celebrity customizing job was transforming Erick Sermon's first Mercedes-Benz. Erick said to me, "You have to customize my Benz and bring it down to the Apollo Theater." My first Friday night in Harlem!

It was the tenth anniversary of Hip-Hop. So I drove the Benz to the backstage area, displaying this showpiece that I put together. And Erick was a big mouthpiece. EpMd was the first dual rap group to go gold. Def Jam was running things, from Run DMC to LL Cool J to EpMd, to the Beastie Boys. I felt like I was in my place; my people and my work in cars were reaching new heights. Here's where I don't mind patting myself on the back a little bit. The thing that I think Unique was able to do at that moment was bring together all the aspects of car customization under one roof. That was my vision and my goal. So that a guy like Erik Sermon or any other client only had to come to me to get everything done at once from the rims to the roof. Before Unique, guys had to go to a rim shop to get their wheels. Then they had to head over to the upholstery shop to get their seats done. Another guy had to do their ragtop. What Unique offered was was the first one-stop shop for your needs.

Of course, I was always into hip-hop from day one. And this was the time in history when the hip-hop lifestyle was defining itself. That was my thing. When you move to suburbia and you're from the city, they call you "city boy." So I was a city boy. You have to represent that right away. I'm from the Lower East Side. We had Orchard

Street there. Everybody shopped on Orchard Street. If you wanted the right fly clothes, if you wanted the kicks, you had to go to Orchard and Delancey Streets, and that was my neighborhood. So we used to shop there all the time.

From sneakers to Jordache jeans, Sergio Valente, all of the sheepskins, the leather bombers, the boots, kicks, belts, hats—I mean, we had it all. So I used to go out there to Brentwood, and everybody would just love my gear. And that's just the fashion part. Then the music part came in. My cousin, Ricky, who is not with us anymore, was into music and was a DJ, and used to go uptown, everywhere—to the T-Connection, the Oil Bar, and the Fever. So he used to go to Grandmaster Flash's and Busy Bee Starski's jams all the time get all the fresh tapes. Mix tapes. Everyone used to argue, "Who's the best DJ? Is it Grandmaster Flash or was it Grand Wizard Theodore?" Then you had cool DJ Red Alert. So this is my era. Music and hip-hop and lifestyle have always been in my blood.

Anyway, the night we premiered Erick Sermon's car at the Apollo, everything changed. The word of mouth was incredible, and we were suddenly the go-to shop; we were getting phone calls from everyone of all walks of life. If you were a rapper, if you were just a regular

person on the block. I mean, I had my guys busy, doing systems, ragtops, wheels, tires. We were just so busy.

So by now I was twenty-six years old. My grandfather was my mentor. I had John Ferraro, Marilyn's uncle, guiding me in the beginning, and Bobby Torino too. But by now, the customization work was taking over; I was doing less detailing, so they weren't around me as much. I was embedded in this aftermarket world, this accessory business of custom interiors and paint jobs. I was so engulfed in that, and I wanted to be the best that I could and make a name for myself. And obviously by working with so many different artists, we were that shop. Everybody came to us.

This was about the point when I first began working with an installer named Keith Rowland, a guy who would become an integral part of my shops and my television shows. The customizing world simply knows him as Reme. When I first met Reme, he was working on a graffiti wall, believe it or not, at my friend Louie Tuminaro's shop, Main Street Stereo. Before my shop, I managed that stereo shop for a while. What cemented our relationship was my personally knowing a guy named Lee Quinones. Lee was one of the greatest graffiti artists in history (you can look him up online). Lee is from the Smith Projects in the Lower East Side.

He was in the *Wild Style* movie, doing the graffiti at the Amphitheater. And he was one of Reme's idols. So that was the connection. I was from the Lower East Side, I knew Lee; he wanted to know more about the people that I knew and how I knew so much about graffiti. And then I wanted to give Reme a little test. I had a feeling we could work together, but I wanted to try things out first. I said, "Listen, I need you to come by my house after you're done here; I've got something for you to do, and you can help me out." I had a set of doors that I needed to be done, so I watched Reme and how he used his tools, and I could see that he was mechanically excellent; he could definitely use power tools, and he was good with his hands and could cut wood. I said, "Listen, Reme. You're working two jobs, you got two kids to feed, and I know you're not a professional stereo installer. But I'm going to start having you do some work for me, and I'm gonna teach you how to be great. We're going to take it one day at a time."

And, sure enough, his first job for me was driving me and Marilyn on New Year's Eve in his old Ford Tempo. Horrible car, it would burn oil and everything. I said to Reme, "Are you doing anything New Year's Eve?" He was a young kid. He had two kids and he needed money.

He goes, "Nah."

I said, "Listen, I need you to drive me to Rocky Point on Long Island. Can you take me and Marilyn?"

He goes, "Yeah."

I said, "I'll pay you a hundred bucks, and you drive me there and back." No problem.

So that was his first job, and when he took the job that night, on New Year's Eve, we started talking about life, and I said, "Listen, I'm going to be opening up a shop. I'd like you to be part of it. I'm going to show you this little rim shop I'm looking at, on the Hempstead Turnpike. We're going to build something special." And I think, at the time, he probably didn't believe me, but that's how Reme got into the game with me in 1999.

There was one artist that I wanted as a client at Unique, and I pursued him until I could make it happen: Busta Rhymes. Busta was from Uniondale, Long Island, and he called his personal brand and label Flipmode (later that would change to Conglomerate). It took patience to get him into the shop, but I knew, I had a feeling, that he'd be part of the Unique family 4 Life. And I was right. Busta was a friend of Bernard, who grew up on Long Island and went to Brentwood Ross High School.

Bernard worked with Def Squad Records and BAM management and Erick Sermon was his client.

So Bernard would say to me, "Listen, Will, I'm going to talk to Busta, and I'm going to get that connection for you and tell him that you got a job at the shop and you're doing Erick's cars over there in Uniondale. You want to do a system. You want to do something with him. Will is going to take care of you."

I said to Bernard, "No problem, thank you!"

Bernard had scheduled two meetings to meet Busta, and they both fell through. I was feeling like this wasn't gonna happen. I knew that Busta was going to really help Unique blow up. I just had that feeling. He was so busy and at the top of his game, doing music with every top artist out there, so I understood. The third scheduled meeting happened. Of course, I had to see him on a Sunday—it's a thing that I always see Busta on a Sunday! I had to open up the shop in the evening. Now here's the important thing to understand about doing this kind of business, and I'm going to discuss it more later: hang time is really important. It's not like walking into a shop and completing a transaction. You have to get to know your client, and they have to know and trust you. So first, we were just hanging out

and eventually I gave him an estimate to put a sound system into his Suburban, and guess what? Nothing happened for like a month or two, but Busta is a very, very loyal person, and so I remained as patient as I could. He can sometimes be spontaneous, but he doesn't just bring anybody into his circle. So it took a month for him to get back to me, and I was like, "Man, am I ever going to get this call?" Sure enough, I got the phone call. He dropped the car off. Reme did a banging ass stereo system on this car. We did the stitching on the Flipmode Squad in his Suburban.

> ## *"You have to get to know your client, and they have to know and trust you."*

Then Busta came to pick it up. Of course, he came on a Sunday evening. We had to open up the shop. It was late. He pulls up, he looks at it, and it's clear we knocked it out the park. From then on he would say, "That's my guy." And Busta said to me, "Will, I'm bringing you another car." That was about was sixteen, seventeen cars later. Almost immediately I began customizing

his Lamborghinis, his Ferraris, Rolls Royces, Maybachs, and we even customized his tour bus—twice! The thing about Busta Rhymes is he's very hands-on. He does let me create with him, but he has his own good knack for design and a very good imagination. He can imagine something, then he wants me to try to create it. His tour bus is very special. Most musical artists rent or lease buses, but Busta Rhymes likes to own his completely, and he's very proud of doing so. A tour bus is like a huge blank canvas. How you customize it, design it, and utilize its space is only limited by your imagination. Busta really put me completely in charge of the process. That meant that I had to go to Florida and meet with the coach building company to spec out the triple slide out bus that he ordered. That means that when it is parked and stationary, the bus expands in three places in the middle and rear separate sections, making it wider and more roomy.

Now for the tour bus, he imagined spinners on the wheels. And this is not something normal, not something you would do every day on wheels and tires this big. But that was what Busta wanted, and I had to execute; there is no talking him out of things or trying to change his mind. Busta wanted to premiere the bus for the first time at a car show that Funkmaster Flex

had created and promoted, and these spinning wheels were so difficult to fabricate and install that we just barely made it. We worked until the very last minute to get them into place. But we were all happy in the end, especially Busta.

At this point, Busta is family. Our relationship has been going on for so long, it's beyond cars now.

Busta was and still is a brilliant self-promoter of his brand and his music. Essentially, I became Busta's car concierge. For example, Busta would call me up and say, "Listen, we're going to Miami for Memorial Day weekend. Make sure you have five of my cars in Miami on Wednesday so we can stunt them out while we're down there, and after we're done on Monday, you need to stay there. And you got to load them back up and bring them back home, and then you can get them ready for the next promotion." It was during trips like these to South Florida that I first met DJ Khaled when he was an up and coming club DJ in South Beach. It was through my long-time relationship with Fat Joe that I met Khaled, and we've been family now for almost twenty years. The first car that I did for him was his Range Rover. Khaled was new on the scene in Miami, but he was already making a mark in the clubs of South Beach. He was happy with my work on

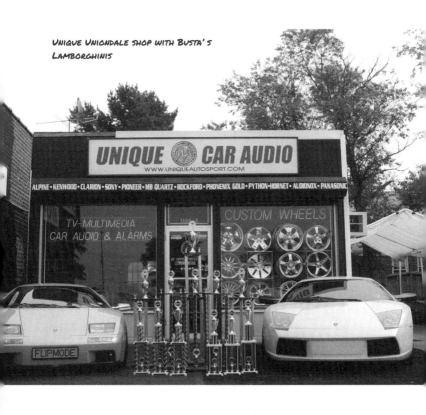

Unique Uniondale shop with Busta's Lamborghinis

his car, and, to thank me, he invited me down to Club Amnesia so he could shout me out. He said, "Will, I am going to make sure everyone in Miami knows you are here!" And he did! It was a fabulous evening, and we went on to do many cars together. I've always admired Khaled's hustle. The guy works very hard (it's not easy), and he deserves everything he's got. Truly, he's been an inspiration to me, and I use his books almost like reference guides for how to walk through this life.

So, Busta had me busy moving his cars around the country. There were constant logistics involved in all the transportation of vehicles. His cars became promotional props, and they were like little stars of their own. And, let me tell you something, when we pulled up with that Unique trailer with Flipmodes and Lamborghinis, it was like filming a movie. It was very big marketing and everyone who cared about hip-hop knew Busta Rhymes was in town.

The other thing that was important to Busta at a certain point was bulletproofing his cars. At that time, in the 2000s, there was a lot of violence, a lot of gunplay. Nobody felt safe anymore, and Busta did not want to be trapped in a tin can and not have any protection. There were a lot of drive-bys in the city, regardless if you were a target or not. Bullet don't have names on them.

In bulletproofing, you can't drill anything because of the layers of Kevlar. So it makes it tougher to run wires and hook up electrical systems. But it could stand up to an AR-15 assault rifle. And Busta's SUV was bomb-proof. He had the works on that truck.

Busta's cars got him a lot of attention, and, by extension, they got me and Unique a lot of attention too. It was at this point that car lifestyle magazines and television networks started banging on the door.

DUB Magazine and *MTV Cribs* were huge platforms at the time, drawing eyeballs to the customizations that I was doing for artists like Busta and Redman, a rapper who was also part of Erick Sermon's organization. These outlets wanted to showcase all the rappers on the East Coast, and suddenly Unique was on a big stage globally. Seemingly overnight, I was no longer a guy seen as just customizing cars locally in New York. People from Texas, Arizona, Florida, and California, were calling my phone number, going on my website because of our appearances on *MTV Cribs*. And we were delivering amazing work that lived up to the hype, creating hand-crafted interiors from scratch. Buju was with me, Reme, Erick, Chico. The guys that I've been with now for twenty years. And, you know, Busta was and still is part of the Unique family. He's very passionate and without

his business, friendship, and support, Unique might not be here today.

Busta Rhymes and I were talking just recently, and he taught me something new I hadn't really thought of. He said, "Will, you've got to understand something. Every ten years, every decade, there's a different type of music. Will, what do you think happened when I came in? The older guys thought 'Here comes this new upstart.' My music is a little weird. But guess what? They accepted it and they got used to it, and it's called art. It's called craft. So now today you've got Migos, you have Kendrick, Childish Gambino. It's supposed to work that way. You have to embrace that as well, just like they embraced my music, and Fat Joe's music. Everybody has certain years. You have to go with the times." And I never really understood that, but he really broke it down for me a little bit, and now I get it and it's true. You have to see how music is trending.

Nas got to me around this time too. Nas comes from a musical family. His father, Olu Dara, is a prolific guitar player who's recorded his own stuff and been an important sideman. Nas himself was only twenty-one years old when he dropped his first album, *Illmatic*. Both Nas and Busta frequented a dealership on Long Island to buy their cars called Power Motors Group. They

and a lot of other celebrities (we eventually ended up doing Robert DeNiro's Winnebago via Power) brought their cars there. Nas saw what we did with Busta's Suburban, and he wanted that kind of treatment for his SUV too. Remember, these were the days before Instagram; everything was by word of mouth. "Let me see it. Let me hear it." In person, not through social media. And Nas came to us that way, and he's become a great customer and friend over many years. Nas loves S-class Mercedes, and we've customized many for him over the years. And SUVs too. The thing about Nas is that he has impeccable taste. He likes his interiors to be designed in a very clean way, everything in its place and hidden from view when not in use. His aesthetic, like his music, is uncluttered.

So I was establishing myself in East Coast hip-hop as the go-to guy to customize cars. Unique was becoming a well-known brand in our corner of the sandbox. I was hustling to get Unique into whatever magazines wanted to feature us. One of our best promotional patrons was Rodney Wills who ran *Car Audio and Electronics* for a magazine group called Primedia. By 2001, the cars we were building were featured on their covers month after month. Wyclef Jean, Rockwilder, Funkmaster Flex, Swizz Beats, and of course, Busta

Rhymes, were all on the cover of *Car Audio and Electronics* with their Unique cars and SUVs. It was also happening inside the pages of hip-hop lifestyle magazines like *XXL* and *The Source*. Eminem and Erik Sermon were in there with their Unique edition cars. By about 2003, Detroit was taking notice. Sometime that year, GM invited me to a conference to sit on a panel about the car customization industry. They flew me in, wined me and dined me, but, very quickly after I arrived, I realized they were not simply wanting to celebrate my work: they wanted information. This aftermarket customization world was a big piece of the pie, and Detroit wanted their own fat slice of it. They wanted to understand what was hip, what their designers were missing. They pressed me for info about lighting, headliners, rims, and tires. I remember dodging their questions, throwing them curveballs. Because for me, this was always about the aftermarket, not about big manufacturers who were already making billions of dollars a year selling cars. I didn't ingratiate myself to them and I paid for that, I think, in a lack of endorsements. But I would not sell out. I couldn't. I wanted everyone in my game to make a living.

"Unique was becoming a well-known brand in our corner of the sandbox."

There was a tattoo parlor next door to us in Hempstead, and, one day, my brother Bobby and I had a few too many beers, and I said to him "Yo, Bobby we gotta get Unique logos tattooed on our arms," and Bobby said there was no way was he doing that. But, just like a big brother can do, I badgered him and I said, "If you get one, I will get one," and Bobby went next door and he ended up getting a really large Unique logo on his arm. Way too big. And he was crying and cursing about how much it hurt and, by the time it was over, I said hello no. There's no way. And so Bobby has a Unique logo with him at all times, and I get to wear mine on my T-shirts. But that's a big brother for you. And that's a little brother for you, too. Thank you, Bobby, for sacrificing your arm in the name of Unique!

Besides hip-hop artists, athletes were the next logical extension for Unique clientele and they came on board, too.

At Unique, we were asking ourselves, *How do we get into the sports field?* But guess what? Again, God blessed me. He opened up those doors for me. It wasn't me that opened up the door. I mean, I had the opportunity, but God is the one that puts people in front of you at a certain time.

So I got a phone call from a body shop in Bayshore; it was from a guy named Blaine, and he said, "Hey, Will, do you follow football?"

I said, "Yeah, of course I follow football."

He goes, "Have you ever heard of Erik McMillan from the Jets?"

I said, "Yeah. Erik McMillan is an all-pro safety. Of course I know who that is. He's the only one who is actually doing it for the Jets. He's the only guy that's making shit happen over there, you know, running back interceptions, and breaking records, and doing kick returns. He's the man."

He said, "Listen, I've got his BMW M3 here, and he wants to do this, and rims, and kit, and a system, and the only one I could think of was you. So is it all right if I send him over to you?"

I said, "Shit, yeah. Hell, yeah. I want that business." So he comes over to the shop. His nickname was E-Mac, and he came over and we sat down and started talking, and ten minutes turned into three hours. I was like, *Yo, this dude is mad cool.* So I said, "E, I want to see your car."

He goes, "Yo, don't worry about it."

And let me tell you something. He's an intelligent guy. He has a master's degree. He ain't your typical jock. This dude is smart. He knows his shit. He knows what he wants. And he said, "Will, I'm going to tell you this now. I'm going to give you my bait. Here's my bait. My M3 is my shit. This is my bait. This is my favorite car."

I was like, "That's what I want. I want your favorite car, because guess what? When I do that one, you're going to be hooked."

He goes, "Yeah, yeah, yeah. Let's talk about it. Let's do a system, let's do a body kit, and I need some wheels."

I said, "No problem."

We do it up, and he told me, "If you do this car, and you do this shit the right way, you're going to have so much business you're not going to believe it."

I said, "Okay. No problem." That ticket probably was twenty-five to thirty thousand dollars.

He came out to the shop, loved the system Sebastian and Clyde did. Sebastian was my manager at the time. He was a big part of this thing, Sebastian was. So Sebastian built a system, tuned it in, had the body kit on there, the rims, tires. E-Mac was in love with the car.

He invited me to the practice facility, to the locker room. He introduced me to Freeman McNeil, Ken O'Brien, Mo Lewis, I mean, the whole team. And from that point on, and we're talking in 1990, from that point on everything changed. We were doing about—and this is no exaggeration—twenty-five to twenty-eight players on the team, and you know football. There're only fifty-two on the roster.

We didn't discriminate. We did practice players, we did coaches, we did everybody's cars. It didn't matter. And E-Mac had me where I could have access to walk in, no ID card, no clearance. I would just say—"Hey, I'm here to see E-Mac," boom, no problem. Go to the football field, go in the practice facility. I knew all the workers in the office. It was the greatest job in the world. I thought, *Man, I can't believe I'm getting paid to do this.* And that's how I became really a Jets fan, to be honest, because how was I going to go against a team that was supporting me and my family? I wasn't! You know, the Giants were out in Jersey! So the Jets were supporting

local businesses on Long Island, and they used to drive all the way to Brentwood to come to me, on Suffolk Avenue. And we were doing all of the brand-new Benzes, all the brand-new Ferraris. They all came to my shop. So we're talking 1990, real quick instant success.

TUNING INTO TELEVISION

I was on top of the world. My business had the biggest hip-hop stars and the best athletes bringing me their cars, and my work was being showcased globally on *MTV Cribs*. I didn't know it, but television was just getting started with me. And, by the time my first show ended, Unique would be at a whole new level that I could never have imagined. The TV thing happened because Busta first made us mainstream with MTV. MTV highlighted that we were *the* shop, a little shop in Uniondale that was pushing out Wyclef, Eminem, Nas, Mobb Deep, LL, Busta, Erick Sermon, Redman, Swizz Beatz—all the top dogs. The list goes on and on and on. And guess where the shop was? Right across the street from Nassau Coliseum. So every time there was a hip-hop concert, where do you think the meeting was? The green room was inside my rim shop. They would eat chicken wings and smoke their weed before they had to get on stage. That was, "Go to the rim shop, go to Unique across the street." Everything happened at Unique—the meetings, the smoke sessions, the Hennessy. It was just a great time, a great era.

One of my really fun times was hanging out with Juvenile from Cash Money Records and Mannie Fresh. They came in and showed us mad love. I'd never even met him. He just walked through the front door and

said, "I heard the shop was here..." We were drinking Hennessy like it was water. The hospitality that hip-hop offered was just crazy to me.

So, as all this was happening, I decided that I wanted to do a local TV spot, and my marketing agency put me in touch with a commercial producer. We produced a local TV commercial for Unique and ran it on Cablevision on Long Island. I put everybody on there, and I didn't catch any bad feedback. So we were running these commercials through Cablevision, a local cable provider, and we were getting a lot of hype for that. It turned out that the guy who cut the Cablevision commercial was named Steve Hillebrand, and he came down and said, "Hey, Will, you've got something special here. I think we can do a pilot and pitch this to Speed, and they'll take it."

I said, "Is it going to cost me any money?" At that time, I didn't know anything about contracts and stuff.

He said, "No. We'll film it."

I said, "Okay, let's do it. Let's do it." So we did a pilot, and sure enough they wanted Unique as a series, on Speed. It was Steve's production company, called Hollywood East. He and his partner put this real dumb contract in front of me, and they wanted me to sign it. I read it,

and it said that the production company would have 90 percent control of Unique, and I got 10 percent. I'm like, "Hold up. So you're taking over my business that I put together? You're crazy. I ain't signing this shit. You're out of your mind."

He said, "Yeah, but we already told the network you're signed."

I said, "Well, that's a fucking problem right there, because I ain't signing this shit." I read three things on that list and I said, "Nope, nope, nope. It ain't gonna happen. You think I busted my ass to give you 90 percent of my business? You're out of your mind. Get out of here with this thing."

They said, "Oh, well, this is called negotiation."

I said, "Listen, this is not negotiable. I don't care what you tell the network, but you ain't got Will Castro. Trust me."

So a friend of mine said, "Here's what you need to do, Will. Me and you need to fly down to Speed, go see Bob Ecker, the boss there, and let him know that you're not signing that deal with the production company. You're only going to sign with the network." So I flew down there to Charlotte, NC, told them what the deal was. And Bob Ecker was from Long Island, so we spoke

the same language. He was all about Unique, Unique, Unique. I met with Bob and with Jim Liberatore, the network president, and Speed's legal guy, Kevin Wilson.

"The Speed team respected me for coming out there...it paid off for everyone."

Ken did a little speaking for me and said, "Hey, listen. Will is not going to sign this deal. It's ludicrous. He needs to sign with you guys directly," and that's how it all went. The Speed team respected me for coming out there. They wanted to do the show, but the only way the show was going to happen was if we got a contract from the network directly. And that was it. The network elected to sign me directly, and that became something of an issue, because now I had Steve Hillebrand producing the series, but I actually wasn't working for him; I was working for the network itself. It was unconventional. So it was a back-and-forth thing all the time. We were able to get through the first season of thirteen episodes. One thing that's important to note here is that the people running Speed had vision

and guts. I was a real throw of the dice. Speed was a network all about NASCAR, the audience for which is pretty much all white men. So to throw a guy from Long Island onto the air who did cars mainly for people of color was risky, to say the least. But it paid off for everyone. We did forty-four episodes with them over a four-year period. And what was really cool about it was that Jim Liberatore was a hip-hop guy. He loved hip-hop music. Jim took a chance. There was no hip-hop at all on that channel, nothing urban. So all of a sudden he came out with this *Unique Whips*, a brash show, with a loud Hispanic guy and a bunch of other crazy guys doing cars for celebrities and hip-hop artists and guys like LeBron James. And he took a chance and it worked for him. I thank Speed, Bob Ecker, and Jim Liberatore for giving me that shot, and I'm grateful to them even to this day. It was also at Speed during that time that I met two other people, Bob Scanlon and David Lee, who would become key players down the road in bringing me to Velocity.

After the first season of *Unique Whips* on Speed, it was just an explosion of business. We were doing ten cars a month. We were blowing out Escalades, Range Rovers. We had our own body shop and paint shop. We had three buildings. I mean, this was blowing up.

*THE WORLD FAMOUS **UNIQUE** TRUCK AND TRAILER PROVIDING DOOR TO DOOR SERVICE FOR CLIENTS.*

Remember, there was nothing else except the cable show. There was no social media in 2005. You had to turn on the box. Nobody saw this coming. They just saw this Puerto Rican guy from the Lower East Side and Long Island doing all these celebrities' cars, and I was suddenly getting phone calls from every basketball team, baseball team. It was amazing. It was the best time of my life. It was an experience, and I started to treat my guys to this, treat my guys to that, take them on trips across the country. It was the greatest time of our lives. It didn't mean there were

not issues. When you're successful, you have to be aware of betrayal. Dishonesty can rear its ugly head. I recall one time when I returned back to Unique after attending a Barrett-Jackson auto auction to find that a two-thousand-dollar Alpine radio went missing from my inventory while I was away. Reme told me he didn't know what happened, but I knew somebody on the team had betrayed me. There's a trust that is built when you are putting food on someone's table and you are part of a team, a trust that should never be broken. Suddenly, it was. I waited until the television cameras were rolling, and I pulled all six of my employees in front of the cameras to confront them about the missing merchandise. It's all documented in an episode of *Unique Whips*. One of my guys, who was like a nephew to me and who I had mentored and treated like family, admitted to the theft, and I fired him on the spot, making him take off his Unique T-shirt and leave it with me before he left. Years later when I was living in Miami, this guy came to me to clear the air, and I accepted his apology and his version of events, but our relationship was torn by permanent fractures. This is why loyalty, above all else, is so important.

"This is why loyalty, above all else, is so important."

As *Unique Whips* was blowing up my brand on television, hip-hop was blowing up around the nation and the world. During that period of time, there was a lot of rivalry in hip-hop; groups were not getting along with one another, because it was so competitive. They used to do battles, but nobody would kill each other because you'd put the competition in a song or in a rhyme. You know what I'm saying? One would come out with another record or another rhyme and try to outdo the other: a competitive battle of rapping. And some people were just a little too sensitive or whatever it might have been, and they wanted to take it to the next level, wanted to make a name for themselves.

And then that's when things started getting nasty and dangerous. And this was after Biggie Smalls' murder. Cliques were not getting along with one another. And then cars in New York were getting shot at, people were getting shot at. You would just pick up a paper and read about some incident, see news about it on MTV News, BET, or *Source* magazine. You'd just read about all these things. But we were so involved in hip-hop, doing their

cars, that we started creating bulletproof vehicles and stuff like that. It just was a crazy time.

People would ask a lot of these questions, because I would be doing everyone's car, but I was neutral in all of this tension in hip-hop. We would be doing Fat Joe's car, we would be doing 50 Cent's car, we would be doing Busta's car, we would be doing Swizz's car, everybody's cars.

I'm in the car business. I'm not in the music business. So my job is to make sure that I'm cool with all my friends, do their cars, and that's it. I don't get into all of that other stuff. I'm not a rapper. So as long as you stay on that level, they're going to respect you for that, and that's why I was able to navigate through all those times, because they knew Will wasn't about that. Will was about doing cars, and that's my passion and love. That's it. And I've always kept everything very professional.

For me personally, that era came to a deadly climax one night in 2006 when Busta Rhymes asked me to deliver a car to a video shoot in New York. I had an eerie feeling about that night; I knew something wasn't right. And frankly, I think God said to me, "You're not going tonight." And I did not go myself that evening.

And I thank God, because I sent a Rolls-Royce to the video shoot down there, for Busta, and then all of a sudden his bodyguard got killed. A twenty-nine-year-old guy named Israel Ramirez. So that was a big deal. I don't know how it happened, but there were so many different cliques at the shoot, and some of them probably didn't get along. I wasn't there, thank God. Who knows? If I would've been there, maybe I could've taken a bullet. And I've got my kids. I wouldn't be here today. I would have left Paige and I wouldn't have my boys right now. I was just blessed and lucky that I wasn't there that night. But I did send a Rolls down there for the video shoot, and, unfortunately, Israel got killed. He was a young guy, a father, just a nice guy. It's sad.

The other side of the coin is that this was also one of the most exciting times of my life. Unique was on top and we had a lot of fun. I recall one time, must have been about 2005, when Busta Rhymes, Swizz Beatz, and I were on our way a video shoot, the two of them in their Lamborghini Murcielagos that I had designed and customized. Both those cars were tricked out with Maya wheels and fantastic Pirelli tires. Each interior was customized with new leather and Alpine stereos. I took a quick snapshot of Busta and Swizz in front of them as we were gassing up the cars, and then each guy

BUSTA'S "PEPPERMINT" LAMBO

jumped in and started racing each other up the West Side Highway. I was following behind. Suddenly, I saw a huge plume of smoke explode out of Busta's Lambo. He had burned out the clutch trying to beat Swizz. That was a twenty-thousand-dollar clutch plus a flatbed tow. I was laughing and crying at the same time.

The TV show, *Unique Whips*, put my store, literally, in your living room. And my business blew up. Now you can just pick up a phone or get on the internet to reach out to me, and I would service you and send a trailer to get your car, whatever you needed. Because of those broken contract negotiations at the beginning of the TV show process, we didn't get along with the first production company, but, truthfully, they did a great job. They were able to take it from step to step and capture the entire process. Each episode was a one-hour show, and I was heavily involved in the production, where they had to get all of my insight. We highlighted each step: picking up the car at the doorstep, ringing the doorbell, saying hello to LeBron, going over the car with LeBron, loading the car into a trailer, coming back to the shop, going over the project with the guys, customizing the vehicle, loading it back in the trailer, flying out to Akron, meeting with LeBron, showing him the car, and getting some jerseys signed.

And then, guess what? That was a phenomenal infomercial for my business. And rappers and athletes saw this on the screen, and my process was revealed to them. They were like, "Yo, that's how Will does business? He flies out, he says hello, shakes his hand, goes over the project, brings it back to the shop, customizes it? He's a ball-buster with his guys about attention to detail. That's my guy, and he ain't playing. He's working seven days a week, eighteen hours a day, everything for the customer." At that time, you couldn't tell me anything else. There was no playtime. It was all about Unique. My life and the lives of my crew revolved around Unique.

We sometimes crossed over into rock and roll, and the biggest example of that was when Mercedes-Benz hired Unique to customize an SUV for the Rolling Stones. It was to promote both Benz's new R Series out at the time and Rolling Stones' "A Bigger Bang" tour. Of course, the most important thing in a build like that is the sound system, and we installed a JBL stereo with the works: huge amp, kicking subwoofer, everything you needed to take "Brown Sugar" to unheard of levels. On a glass plate on the front surface of the subwoofer, the Stones signed their names in ink. And, among other details, we added embroidered Rolling Stones lips to

the headrests and the floor mats. I often wonder what has happened to some of the many cars I've built over the years, and the Rolling Stones Benz is one I'd love to see again. I have no idea where it is now.

INTERIOR OF THE ROLLING STONES' UNIQUE MERCEDES-BENZ SUV

We also crossed over into mainstream television. One of my most lovely clients during that time was Pamela Anderson, star of, among other things, *Baywatch*. I

knew a guy who was a driver for Pam, and he called me up one day and said, "Hey Will, would you be interested in doing something with Pam Anderson?" And of course I said yes. I was a fan of Pam's; she was gorgeous and was the reason I watched *Baywatch*! So Pam called me, and it became clear that she wanted to makeover an old Airstream trailer that she owned. The thing was in bad shape, but she had a vision for it. She wanted it clean, white. Nothing too garish, no animal prints or anything like that. But she also wanted it to be fun. She wanted a disco, retro 1970's feel and look. Like Studio 54 in a trailer! She asked for a disco ball, bar, white shag carpet, mirrors, the works. You name it, she wanted it in there. I said to her "no problem." There was also a private cabin in the vehicle, and Pam told me in there she wanted a stripper pole and a custom-built round bed that would vibrate. And she wanted the lighting in the rear cabin to be pink. I'm laughing to myself as I think about this, because Pam was very precise. We decided to call the trailer the Lovestream instead of an Airstream. Pam's Lovestream. It was a big job and physically it took a lot of work. There was cabinetry, flooring, new tires, new rims, you name it; we had to build this thing basically from scratch. She said to me, "When this is done, I want you to bring this to me in

Santa Monica, and we're gonna throw a party. And, Will, when I say we're gonna throw a party I *promise* you, I know how to throw a party. I'm gonna have the Playboy Playmates there." I'm thinking, *Oh my God, no problem.*

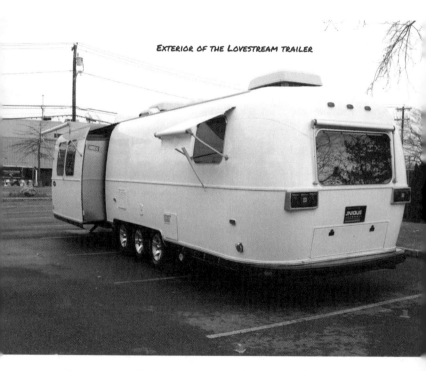

EXTERIOR OF THE LOVESTREAM TRAILER

Once we built the Lovestream in New York, we had to get it across the country to California, and I had my daughter's godfather, named "G," drive the trailer back

UNIQUE HUSTLE

to California. It was an ordeal. He got pulled over a few times, then he had to get it through the desert in Arizona. It was a mission to get there, but he finally did. I flew out to California and saw Pam, and she said to me, "We have to reveal this properly for *Unique Whips* with the cameras rolling and really christen this thing."

I said, "You're right, what do you need?"

She said, "A couple bottles of Cristal."

Again, I said, "No problem." It wasn't in the production budget, but, of course, we wanted Pam to be happy. Happy Pam, Happy Will. A great scene for the show.

The scene went great; we had a fantastic reveal on camera, and then we moved to the private cabin. The cameras were still rolling, and suddenly Pam started spraying the Cristal all over the cabin, the new bed, her friends in the scene, me; it turned to utter chaos. Now, I'm laughing out loud thinking back on this. And I'm thinking to myself in the moment this is great television. We were rolling around on the floor. But I suddenly realized we needed to calm this thing down; we're starting to ruin the job we just finished. And I got everybody to chill out and take a breath, and Pam looked at me and she said, "Will, we can take a break, but I got some celebrities and the Playmates coming

over later, and we are gonna turn this shit up!" And to make a long story shorter, we did. We had a party that night, big time. Pam is an amazing person; she's always treated me well. I've seen her here and there over the years, and we always have a nice moment together whenever we run into each other. She is a great mother; she used to go to baseball practice with her son and always put him first. Pam is really a down-to-earth, lovely woman. She's got that laid-back Canadian vibe, and, once you know her and she knows you, Pamela Anderson is mad cool. Eventually she auctioned off that Lovestream for charity. It was a memorable project for me, one I'll never forget. Pamela made sure of that.

I also worked a lot with cast members of *Jersey Shore*, mainly The Situation, when they were filming in Miami. He and his family were just getting into the car game at the time, and he bought a couple Bentleys, which we customized with great stereos, rims, and custom stitching on the headrests that said "The Sitch." He was very family orientated, and I met his mom, his brother, everyone. They took me in during that time, and I got to know them all. Obviously, Sitch had his demons and was going through some stuff at the time; there were some people around him that took advantage, I think. But he was a very big car guy and we got to know

The stripper pole Pam Anderson ordered for her Unique Lovestream trailer

PAMELA ANDERSON AND WILL

each other through that. He loved fast cars, Ferraris, Lamborghinis; you name it, he had it as long as it went fast.

We also did cars for JWow and Pauly D. These guys were all a huge TV sensation and the cars that I did for them ended up on magazine covers like *Dub*. In their own way, the *Jersey Shore* cast is a great American story of people who came out of nowhere and turned into an amazing piece of pop culture. One thing I'll never forget about Pauly D is that he was a Patriots

fan. So I bet him once that the Jets would beat the Pats, and, if they did, he had to DJ at his next club gig wearing a Unique T-shirt. I won! And he did it; I have a picture of it in my archives.

Unique Rides on Speed went on for forty-four episodes. The television business can be tough for the people in it, it's like a revolving door of executives coming in and going out. By the time we hit forty-four episodes, Jim Liberatore was gone and another executive in charge had come and gone too, and it was clear to me that they were not green lighting more episodes. But, of course, I still wanted to be on TV, and we had contacts at Viacom which owned MTV and Spike. And Spike responded well; they were interested in picking up the show because they were doing car programming at the time. So we moved to Spike and a new version of the show premiered there.

By this time, it was 2008 and that's when I opened my door one Sunday afternoon to see two federal agents standing on the other side.

The Situation from Jersey Shore and his Unique Bentley

CHAPTER SIX

THE THREE KINGS

I'm grateful for my clientele and for the chance to work with some of the most talented people in sports and entertainment. It's not always easy. Personalities are difficult sometimes. And once in a while, money issues come up. I remember the time an athlete stiffed me with a really bad check. It was a lot of money, and it bounced hard. I don't want to say his name; it was a long time ago, and he's retired now. Plus, I still do business with the teams that he played for. When he asked me to customize his Jeep Cherokee for him, I did. We sprayed a fantastic paint job, added a body kit, new rims and tires, and we installed an incredible stereo. The car looked amazing; I delivered it to the training facility, and this baller was thrilled with the results. He handed my delivery man a check for fifteen thousand dollars. Bounced right away. This upset me, of course, most especially because it was around Thanksgiving and I wanted to get my guys each a turkey to thank them for all their hard work and I had to pay for my own holiday, too. Now I didn't have the money to do it. I called this guy over and over, and he would not get back to me. I left messages with the team's front office. I left messages with the ball boys who took care of the equipment. Any way I could find to try and get word to him, I did. I knew the messages were getting

to him, and he was simply ignoring me. So I formed a plan to get the car back. I wrote a note on the back of my business card saying, "I've got the car, it's safe. Your check is no good, so please call me to settle up the bill." One of my guys went down to the practice facility, left the card in this player's locker, and drove the car back to my garage.

> **"I'm grateful for my clientele and for the chance to work with some of the most talented people in sports and entertainment."**

Well, very shortly thereafter I get an irate phone call from this guy screaming at me, "Where's my car? My clothes are in the back seat! My toothbrush is in that car!"

I said, "Listen to me; the car is safe in the back of my garage. All you need to do is pay me with a certified cashier's check and we're done; you can have your car."

He's still screaming, "I'm coming down there! We've got a big problem!" So I said to come on down. And

he did. This guy showed up with another teammate and client of mine. And he was hot, angry, and riled up. Honestly, it got very heated. The guy tried to throw a punch, although it didn't land on me. He wanted to call the cops, and of course I said he should go ahead and do that. So the Suffolk County police eventually showed up, and it turned out to be a cop that I went to high school with who was a friend of mine. He really helped get this baller to calm down, and everybody took a long, deep breath. Again, I reiterated my position. All I needed was certified payment, and this guy could have his car. But this player kept making excuses like the bank was closed and it was a Friday. He just would not commit to finding legitimate payment for me. So I came up with a plan on the fly. Remember, this guy had brought his teammate with him to ride shotgun on this misadventure, and I turned to him and said, "Listen to me, I know you, we've done business together. Why don't you front your buddy the money? You pay me, and all this gets settled. I'll take your check."

This was a big guy, and his eyes lit up and his jaw dropped because now he was getting financially involved! But he did it; he cut me a check for the work, and, as they were getting ready to leave, I remember him saying to his pal, "I'm not playing with you. You *will*

get that money back to me." This goes to show you, even some athletes struggle with money. But this is not obviously how it usually goes down.

The average Joe on the street may expect a shop like mine to be like a dealership, with a guy sitting behind a desk ordering parts on a computer. That's not the experience you're going to get at Unique. It's going to be more personable. My client comes in, and we might sit around on the couch and talk about music, talk about the game that was on last night. We kick it like that first. Then later we get into the needs of the car. And I'll just give him my ideas, and then he'll be like, "You know what, Will? Yeah, let's go with that." So in that respect, I'm more like a car lifestyle consultant. And my clients, by the nature of who they are, are demanding of my time and effort, just like you would be with a concierge at a fancy hotel. And here's something very important—trust is the biggest factor. In this ultra-luxurious car world, if a client thinks I'm only interested in making the sale and then so long and thanks for everything, I've failed completely. I don't operate that way. After the car leaves, I have to be ready twenty-four hours a day for that phone call. Because the cars that I build are not museum pieces; they are being driven every day. One day, I received a call from

Mark Labelle of Shady Records, and, the next thing I know, I'm talking to Eminem who is trying to get his car stereo to work for his daughter. I had to talk him through it. And frankly, it's a privilege for me. Most people in the auto industry don't get to work every day with Busta Rhymes, Billy Joel, Nas, Pamela Anderson, and other artists and entertainers like them. So there's a trust factor there. This kind of client is going to call you at all sorts of times of the night; they don't want to deal with a dealership that's closed. One night, it was Busta saying a cab had hit his car and he needed another car delivered to him immediately. Another night it was Fat Joe telling me he had a flat tire and a cracked rim, and he needed help on I-95 right away. And they're able to get the hotline directly to me, and they're going to say, "Hey, listen, Will. I just got a flat. Send me a flatbed to come pick up my car. I know it's two in the morning, but guess what? I know that you're going to handle it. Good night." And that's it.

"Trust is the biggest factor."

There are always other kinds of requests, too, when you are as much a concierge as you are a craftsman.

For example, I remember a funny time when Jermaine O'Neal was traded to the Toronto Raptors, and he was going to leave the USA and base himself in Canada. I got a call from Jermaine and he said to me, "Will, you gotta get me all the Cocoa Pebbles that you can; they don't have that cereal in Canada." Jermaine loved Cocoa Pebbles. So I got in his car and went from grocery store to grocery store to grocery store and filled his trunk with countless boxes of this cereal. When he drove the car into Canada, I'm not sure if they looked inside the back, but, if they did, they would have thought he was a Post cereal distributor. Or a Flintstones nut. Anything but a star basketball player. But I got it done because they want that kind of attention and service. And I do it with the help of multiple cell phones, usually three!

There's another great story I'll never forget about, about A.J. Burnett, the major league pitcher who did seventeen seasons in baseball with teams like the Pirates, the Marlins, and the Yankees. We built a few cars for him over the years, and one of them was a wide body Charger with a Pro Charger supercharger system, Borla exhaust, booming Phoenix Gold stereo system, and Forgatio custom wheels with Nitto tires. The car was sprayed all black with red accents using BASF, RM Paint. It was a sweet ride. The day I'm thinking about

A.J. Burnett of the NY Yankees

is in the history books: October 29, 2009. It was game two of the World Series with my favorite baseball team, the Yankees, taking on the Phillies. A.J. Burnett was scheduled to be the starting pitcher that night in his first ever appearance in a World Series game with the Yankees. He decided to drive the Charger to Yankee stadium, and something went wrong in the Bronx. The car died on the way to the biggest work day of his life. I was in Miami at the time, and I got a frantic call from him on the side of the road. He was panicked. "Yo, Will, my car is dead, and I have to be at Yankee Stadium in fifteen minutes to pitch!" I kept my cool, like a doctor going through the possibilities of what could be wrong.

"Do you have enough gas in the tank?" I asked. He told me he did. We went through a checklist of what could be going haywire. Nothing. The car would not turn over. I had to come up with a plan fast. Not only was my Unique reputation on the line, but the Yankees in the World Series were at stake too. Thinking on my feet, I called a buddy, Tim Martin, who had a Cadillac dealership in Edgewater, New Jersey, just about fifteen minutes from where A.J. was sitting, stalled and helpless. Tim sent an Escalade to A.J. and A.J. hopped in, speeding on to Yankee Stadium. The driver sat with the broken Charger and waited until the flatbed came

to tow it away. At first, we thought that A.J. had blown out the supercharger by pushing it way too hard before it was properly broken in, but we soon realized that the fuel pump had given way for whatever reason. That's what did him in, in the wrong place at the wrong time. To his lasting credit, A.J. went on that night to pitch seven innings and win the game, and the Yankees went on to win the Series that year. Amazing when you really think about it. And he very nearly did not make it to work on time that day.

I have the best clients on earth. I refer to one group of them as The Three Kings: P. Diddy, LeBron James, and 50 Cent.

Sean "Puff Daddy" Combs (I call him Diddy) is a real visionary. I've done many cars with him, but the two that stand out the most in my mind are twin Jeeps that Diddy asked me to do during a time when Jeeps were not at all popular. But he knew what he wanted, and he knew why he wanted them. He was going to *make* them popular. And *make* a statement. Diddy is someone who really understands his brand and how to build it. In some ways, he's like a modern Andy Warhol. Diddy said something to me like, "Will, we're going to kill the market with this. Let's make these two Jeeps that go back in time to a *New Jack City* era and just

make them with a new flavor, a new touch, still have the doors off, shorts, sneakers outside, the running board, just real cool and stylish." Man, we killed that together. Here's the thing with Diddy—he knew he wanted Jeeps that were urban cruisers with plush leather seats, incredible sound systems, open air without the roof. People at the time did not see Jeeps that way. They saw them as off-road vehicles, driving over rocks and through streams. But the way Diddy envisioned it to me, you would think he ran Jeep! He is brilliant in business. One day it may be automobiles, but on others it could be spirits, like his vodka, Ciroc, his tequila, DeLeon, or his clothing line, Sean John. That's how he's been so successful in his life—taste, quality, and design. Every time I was around him, I was a sponge. He's very demanding, and he wants to get the best out of you. And, sure enough, he's always done that when we've worked with him at Unique.

Diddy wanted two Jeeps at once and he envisioned them like Siamese twins joined together; one had to go with the other as if they were born only minutes apart. Now, I can't tell you that everything rolled exactly according to plan. In fact, when we first presented the cars to Diddy, he did not like the sound systems at all. Diddy has very precise ears, as you can imagine, and he

thought these stereos were not loud or clear enough. So we had to pull them out and completely start over again. New amplifiers, new receivers, new subwoofers, new tweeters: everything had to be changed and upgraded. And eventually we made him happy. When we finally unveiled them in the city, it was lights out! A big splash in the car world. Lots of haters at the time said, "Oh, I could have done that." But they didn't. Diddy and Unique were first. And once we delivered those cars, I was married to those things from New York to Miami and out to California. First, we had to ship them to Florida and to Star Island. Remember what I wrote about concierge service? We had to service them. We had to take the tops off, take the doors off. He even had a parking spot in Manhattan just to prep and service his Jeeps. Talk about maintenance. His driver would call me up and say, "Hey, Will, he's going to take the Jeeps out. So you got to take the tops off and the doors off. Send your guys out ASAP." We ended up doing a lot more cars with Diddy.

When I first met LeBron James, he was only eighteen years old, a kid just out of high school who was playing in his rookie season in the NBA. He was a round one/number one draft pick in 2003 from Akron, Ohio. Back then, I knew LeBron would be a fantastic baller. But no

WILL AND SEAN "PUFF DADDY" COMBS

one could have predicted the kind of superstar mogul he would become, a man whose name and talent would be held aloft with all-time greats like basketball stars Michael Jordan and Kareem Abdul-Jabbar as well as with entertainers like David Geffen and Jimmy Iovine. I met LeBron through Jermaine O'Neal, who played for the Indiana Pacers and who was a dear friend of mine after first being a client. Jermaine and LeBron got along well because they were both drafted at the same time right out of high school, and so they were kindred spirits. And when it was time for LeBron to deal with his cars, Jermaine sent him to me. I was impressed right away with LeBron's intelligence, his sense of himself, and his vision for his brand. And he's just a great person at heart; he wants to see everybody win. When we first met, LeBron was surrounded by a great team, and, even in those very early days, you knew he had good people around him. That's one of the keys to success, having the best possible support surrounding you. It applies to any walk of life whether you're an athlete, a business person, a creative-type, or even if you customize cars.

The first thing we did with LeBron was his Hummer H2, and that was a car he got when he was still in high school. LeBron wanted to make it Unique. One of the

WILL AND LEBRON WITH HIS UNIQUE FERRARI

ways we did that was to take the original champagne color and paint it black. And we put a stereo system in there for him. But the signature lick for that car was the thirty-inch rims I put onto it; they were the biggest size to ever hit the market and were made by a company called TIS. We put Pirelli tires on the wheels, and those tires were rare at the time; no one made tires that big for a street truck like that.

The next job for LeBron James was the first exotic super car that he bought for himself, a gun-metal gray Ferrari. LeBron purchased the car in Vegas when he was playing summer ball for the NBA. He sent me some pictures and told me we needed to customize the car ASAP. He bought it without even test driving it, which happens a lot in my world. The first thing LeBron needed was to fit in the car: he's almost seven feet tall. So one of our main jobs was to custom fit the seats in such a way that he could comfortably sit in the vehicle. We fitted him for the car like you would fit a tailored suit. Everything in the car was stock, but LeBron wanted it to be Unique. So the next thing we did was a custom interior and floor mats with his branding on it so it truly felt like a LeBron James custom car. We did special badges and a JBL stereo system. When it was all done, LeBron still didn't really know how to drive

the car. So I went out to Ohio to give him lessons in using the paddle shifter and demonstrating for him how to drive the vehicle. Teaching LeBron James how to drive a Ferrari is one of those moments that I will always remember.

I met 50 Cent through Busta Rhymes before he was shot nine times and almost died. 50 came to my Unique grand opening in Hempstead with Erick Sermon.

50 Cent wound up signing with Chris Lighty, the founder of Violator, a hip-hop management company. Chris is not with us anymore, RIP, but he was one of the pioneers of one of the greatest management talent agencies in the world of hip-hop. So as 50 Cent's manager, Violator would call us if 50 bought a car, and we would customize it for him. (Then 50 Cent bought his mansion in Connecticut from Mike Tyson, and Unique ended up redoing the whole mansion for him, all the design work on that.) 50 is one of the first ever to do a Gucci room which we were happy to do for him, and it was featured on *MTV Cribs* as a two-hour special. 50 was the only artist on MTV to ever have his own full show on *MTV Cribs* because usually they would have three different talents per episode. But 50 Cent got his own hour. I feel blessed to have worked with him so extensively. He's such an amazing artist

who has persevered and remained strong in the face of adversity.

One thing I have to admit that I really messed up with and felt terrible about was something that happened with 50's chrome Lamborghini. At Unique, we built him his first chrome Lambo, and, when it was time to give it back to him, I forgot to take the Unique temporary plate off the car and put his actual New York state license plate back on it. We had just finished shooting some film with it, and, of course, you're never going to want to show the actual plate when filming a car. It was my mistake, and it was huge. 50 wound up driving around Fifth Avenue in the city during Fashion Week and getting pulled over by the police officers out there. And he didn't have a tag on the back. He had the Unique tag.

I got a phone call while I'm in my pool house. It's James Cruz, screaming at the top of his lungs, "You're going to get me fired. You just got 50 arrested. You're in a lot of trouble."

I said, "Oh shit. Are you serious?"

He goes, "No, I'm dead serious, and 50 is pissed."

And I'll tell you this right now. Every time I do see him, he does mention that incident to me. You know,

he's gotten over it, but he doesn't forget because he reminds me about it, "Oh, you stupid ass, you got me arrested."

And it was in every newspaper, every *Daily News, New York Post*. Now, in every publication, you can see 50 getting locked up in front of his chrome Lamborghini

50 Cent with his custom chrome paint from Unique

convertible with the Unique tag. He was not happy with me for a long time about that.

But 50 got over it. I've got mad love for him. He did a lot of great things for me. He helped me build my brand as well, just like LeBron did, just like Busta did. I've been very privileged to know all of these young stars when they were coming up. And now they're dads. They're older. They're entrepreneurs. They've all survived and come into their own.

And when I watched 50 Cent on Starz in *Power*, I was thinking *This guy is just amazing.* This guy came from the south side of Queens and made something for himself. You know what I'm saying? And I look up to people like that. That inspires me. I've been very blessed and fortunate and privileged to be able to work with these icons when they were exactly at their hottest points. I happened to be at the right place at the right time when their brands were exploding and they were taking over the world. I'm fortunate and lucky. And very grateful.

WILL AND 50 CENT TEST DRIVE A CUSTOM GOLF CART
THAT WAS CUSTOMIZED FOR 50 MANSION

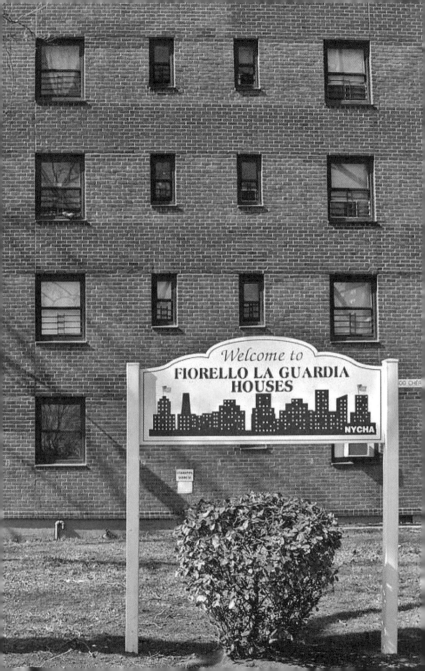

CHAPTER SEVEN

BUSTED (AND MIAMI)

When the federal agents left my house that day, I was definitely frightened. I was worried, about my future, about my family. I didn't have all the tools. I didn't have a father figure where I could go, "Hey, Dad, you know, they knocked on my door. I didn't pay some taxes."

And he would say, "Well, you're supposed to do this and do that." I didn't have that guidance. I didn't have that person, that somebody who would actually advise me and coach me in the right direction.

It's a felony if you don't file taxes three or more years in a row. I didn't know that. I was thinking that paying quarterly taxes was enough. It's a lot of paperwork, and I wasn't great in the administration area when it came to admin stuff. You really need somebody to handle all of that. My business, Unique Autosports, was legitimate. I wasn't doing anything illegal there; I just failed to file the paperwork and pay my fair share of taxes for my employees. Looking back, there was really no excuse. The truth is that being a public-school kid from the projects of New York City caught up to me. My real education was on the streets of the Lower East Side, but that wasn't enough for the place in which I found myself. In that dark time, I had a few people around me; I've been very blessed. Hector, my attorney, would talk to me at two in the morning if I needed him, off the

clock. It was just friendship. And James Cruz, the hip-hop talent manager, was there for me too. Hector and James kept telling me that I was going to bounce back. They are the ones that gave me the confidence and the WillPower to keep on striving, that there was going to be a better light at the end of the tunnel.

It was at this time that the TV show moved from Speed to Spike, and it was also when I decided to move to Miami. The idea was that I would go first and get established and then Marilyn and Paige would follow me. Going through all the legal issues, I needed a change of scenery, a place where I thought I could reboot my life. The pressures were enormous. On top of it all, I was facing bankruptcy. But I still had clientele. I still knew how to make popping kick-ass cars, and I still had Spike behind me for the time being. Also, my mom and brother were in Clearwater. I had family in the area. And there was a huge client base, especially athletes, in South Florida. So it made sense for me to go to Miami to try and make a fresh start. For me and for the new version of the TV show. So I opened a Unique shop there with the help and support of a tobacco magnate named Robert, who also owned a rental car company. He liked the idea of associating that business with Unique and the celebrities we brought in the door,

UNIQUE SOUTH IN MIAMI, 2008

so he gave us fifteen thousand square feet of space to create Unique Miami.

All the while, I was flying back and forth from Miami to New York to deal with the IRS issues.

There were a lot of people telling me that I wasn't going to make it. But with my personality, if you tell me I cannot do something, that's when I kick it into an entirely new gear just to show people, and myself, that I can accomplish whatever I want to. I'm not saying it was easy. Because my troubles were so deep on the IRS front and my personal life was beginning to fall apart,

I drank every night I lived in Miami. I was stressed. I wanted to forget about the legal issues, the bankruptcy, and I drowned it all in alcohol.

On the other hand, Miami really embraced my coming down there. The community welcomed me with open arms. Everyone in the hip-hop community, all of our clients were there for me. One of my biggest supporters was Fat Joe, and he showed me around the 305. Joe took me to DJ Khaled's radio studio in Miami and shouted out on the air that Unique was in town and open for business. The folks in Miami knew what I was going through, and they stood by my side and gave me mad support. And it was almost unheard of in the television business that I could step from one network to another. The Spike deal happened, and we were still on TV. In fact, we were also licensing the show to regional Fox Sports networks; they were paying us so they could air reruns.

Miami was working for Unique, but it was not working for me. At some point, I realized that I was just running away from my troubles by being there. I was hustling, working really hard to try and crawl out of the hole that I'd dug myself into. I was sleeping in my office on a ratty old air mattress that kept losing air in the night and waking me up. My employees felt so badly that they

WILL CASTRO MEETING YOUNG FANS AT THE MIAMI BOYS AND GIRLS CLUB IN 2008

all pitched in and bought me a real mattress. I recall one night lying on this thing looking at the ceiling by myself. It was maybe one o'clock in the morning, and I was saying to myself, *What the fuck am I doing here in Miami? What am I doing? Is this what it's all about, to just make money, take care of my clients, and not be with my family or my daughter? This is not what it's supposed to be.* And I was talking to God, and I was talking to my grandfather in heaven. Was I fucking up? What was going on here? Everything was spiraling. It really was. Something was missing, and that was my daughter. She wasn't with me, and I didn't have my partner sharing this with me. And I believe it was that very week that Marilyn emailed me saying she wanted a divorce. And, of course, that sent me through another loop. We had been together since we were teenagers. We had an understanding that when I moved to Miami, if the business was a success in a year, we would sell the house and Marilyn and Paige would come down. Well, a year and four months went by; we were successful, the TV show was successful, ratings were great, they wanted a second season, and Marilyn wasn't moving down. She just had a change of heart and fell out of love with me.

"At some point, I realized that I was just running away from my troubles."

During this very dark period of my life, a gentleman named Dave Trombley really stepped up and straightened me out. Without Dave, I may not have made it. I met him through Marilyn and her family. Dave was a businessman who had had a successful meat packing company in Ohio. In the past, I'd always had my grandfather, Facio with me, but he was not around to help me get through this tough time. Papi was always that shoulder I needed. And he was all about law enforcement and the government. He was a straight guy, but he was gone by the time these troubles happened. So Dave was about the age of my grandfather, and I was blessed that he became the grandfather figure I was missing. He stepped in and was like a mentor to me. And he said, "Will, you've been doing this all wrong. I know that you're very talented in what you can do, but there are certain things that you need to be doing better. You need to have a better team around you, and it starts with better attorneys, better accountants, better all of this. You've got to have

WILL'S HUMBLE BED IN MIAMI AFTER THE BUST (WITH PAIGE'S PINK BLANKET)

these kinds of people around. You're going to be fine because you're a good person, but you made some mistakes and you were naïve about them. You just need to get this all right."

And I said, "It's easy for you to say. I'm the one that's being investigated."

He goes, "Nope, that's okay. We're going to go up and see this law office where I know some people. We're going to go to Manhattan, and we're going to see what's what." And, sure enough, he took me to one of his tax attorneys in Manhattan, and these guys were amazing. They explained about tax laws and what I was doing wrong.

You had to comply. Full compliance. They want to know you're there. They want to know that you're acknowledging them. That's what you have to do as a US citizen. So, you know, I learned a lot and I made a lot of mistakes, and I could really own up to that. I made a lot of mistakes. I think it made me a better person.

I had about six attorneys, and one of them was named Judy. Judy said to me, "Hey Will, I'm going to be honest with you. You're going to be paying the government for a minimum of fifteen years. It will be tough. It's going to be a hard road for you. But if anybody could do it, you

can. I can see you. You're a hard worker. You're a good person. It's not the end of the world but you will be paying for at least fifteen years." And you know what? She's totally correct because I'm still paying, and that's what it is. It's a tough road.

At the end of the day, I was charged with failing to collect withholding taxes from my workers. Whether or not I was going to go to jail was completely up to the judge, but, just in case, my lawyers had me choose from three different federal prison facilities so I could take into account proximity to my family: one in New Jersey, another in North Carolina, and a third one in Alabama.

So we wound up going to court, and I got lucky by having a good judge. And I remember that day, clearly, and it was the scariest day in my whole life. I woke up in the morning and went down to the courthouse with my entire family. And those people were there to support me. My mother and brother and Sheila, my girlfriend, were there, and I was scared from the moment I woke up in the morning. And that judge, I'll tell you, she could've said, "You're going in" or "You're going home." I sighed a heavy heave of relief when she told me that I was going under house arrest but not to jail.

I had to pay every dollar back. In court, I said, "I apologize. I was wrong." I pled guilty. It was wrong for me to do what I had done. It was a hard lesson to learn, but I had to pay back all the money that I owed the government, and I had to borrow money from family and friends to get the situation resolved and under control.

In the end, I was sentenced to eight months of house arrest with a collar around my ankle. How did I escape jail? God. That was God's doing and I am thankful for that. I think also that judge wondered how I was going to pay the government back if I was in jail. That's pretty hard too. So they probably looked at the situation and said, "Hey, listen. Will's going to bounce back. He may come back on television. We don't want to hobble him in the business, but he does have to pay us back. Let's not take him out of the game completely." But I went bankrupt. And my wife left me. That's the triple killer right there. Divorce, bankruptcy, and almost going to jail. I mean, not many people get out of that and live. People jump off roofs for that.

I did think my world was ending. I thought my life was over. I'm not going to sit here and pretend that those thoughts didn't cross my mind. But I thought of my daughter, Paige, and there was no way that I was

going to go the easy way out and not be here for her. Life moves on, regardless if you're financially busted or homeless. At least I had life and was breathing. I mean, come on. There is a lot of truth to that. I don't know how people could do that to their kids. How could you be so selfish? I feel, because I have three children now, there's no way I could ever see myself not wanting to spend every day with them. Or speak to them, be there for them. It doesn't have to be financial. You just need to be present.

I had a probation officer and had to go down to the headquarters, and they charged me for everything. I had to pay for the ankle bracelet. I had to pay for the monitoring service. I got a bill for everything. And, you know, they strap that thing on you, and they tell you the dos and don'ts. They give you a sheet of instructions. They write up reports. They monitor you. They come and visit you. They do random visits, and that's it. And they have like a little radar, a little transmitter, and if I went past a certain amount of feet from my apartment, that would send a transmitter signal to the headquarters and I'd get a phone call. That's a phone call you didn't want to get.

I chose to stay in an apartment in Long Island City, just across from the city, for my entire house arrest.

I wanted to be close to Manhattan, to be able to work and stuff like that, and I wanted a change of environment. I was embarrassed. I was embarrassed for my family, my daughter, all the people who were close to me. So I didn't want to be anywhere near where I used to live on Long Island. Plus my father had just passed away about a year and a half earlier, and I just wanted to find myself. I had to do some soul-searching, and I felt like going back to where I was from would maybe make things better for me, mentally.

"I just wanted to find myself."

And it did. Sometimes things come back 360 and you just need that. But that was why I picked the apartment just across from Manhattan, in Brooklyn. I turned one of the bedrooms into an office and started working out of there. My right-hand guy, Jimmy Bibbee, would come every day and help me out. Jimmy was locked up with me! And Jimmy and I laugh about this, but it's the truth. He went along the whole ride with me. He would come to my apartment jail cell. We called it the cell block.

It's twenty-four-hour lockdown, and you have to stay inside the apartment. My range was from the apartment door to right before the elevators. I couldn't even dump the trash in the chute in the hallway, except at certain scheduled times. One time I had to go throw the garbage out and totally forgot about the timing, and they called me on it.

There were dark nights in that apartment, a lot of prayers, and trying to be a better person. But then I would look at the bright side and say to myself, *Wow, this car business has taken me literally around the world. I mean, a local kid from the Lower East Side that went around the world—just customizing cars— is amazing.*

MAJOR SETBACK, EPIC COMEBACK

I was down, that's for sure. The lowest point in my life so far was living with a collar around my ankle, not knowing what would happen next and if I could ever bounce back. I didn't know it at the time, I was under house arrest, but I still had more ups and downs to come. As I sit here writing this now, I'm philosophical about this latest decade of my life. Perhaps the best life lesson in my story is to try and stay even keeled through all the storms. Don't go too high with the highs, and never go too low with the lows. During this period, I had a lighthouse standing strong on the shore, shining her beacon of light down on me and helping me to see the shoreline and avoid the rocks. That was Sheila.

"Perhaps the best life lesson in my story is to try and stay even keeled through all the storms."

I met Sheila Afzali many years ago, somewhere around 2000, in Uniondale. Sheila was a bartender at a P.F. Chang's near my shop, and that was a restaurant where my guys and I used to hang out and get our apple martinis. Jimmy, Reme, Chico, Buju, Eric, Bobby, we

all went there as a group and knew Sheila because she waited on us regularly. Sheila started hanging out with us as part of the group. She had these little bangs, beautiful complexion, beautiful eyes, amazing eyebrows. She was very, very attractive, but I wasn't attracted to her as in wanting to go to bed with her. I was attracted to her for companionship, and her big heart, her smile, and how warm she made me feel. She listened and was just cool to talk to and hang out with. So she was like a sister of ours, from Unique, from back in 2000.

It was never sexual between us, obviously. But I did enjoy her companionship as a sister: that kind of woman friend that many guys have who offer a female's perspective on things. Somebody you can have conversations with about silly stuff. That was Sheila. And then she left Uniondale. Went off to nursing college and began her studies; she eventually became a registered nurse working in oncology—treating cancer patients with chemotherapy. After that period of P.F. Chang's, we lost touch completely.

Fast forward to my time in Miami: it turned out that Sheila had been living and working in Miami for seven years, and she saw me on TV and realized that I was in Miami too. So Sheila called up a mutual friend named

Chris Hayes, and said, "Hey, Chris. I didn't know Will moved to Miami. He has a TV show."

And, of course, he's like, "Yeah, he's on TV. He's got a shop and everything."

She was like, "Well, you need to connect me with him. I don't know that many people out here from New York, and I've been here for seven years. I would like to see him."

So she called me. One thing about Sheila, she's like a social butterfly. So I would always call her 'cause she was like my sister. So we started hanging out a little bit. She would come out with me and the guys and have a drink with me, Troy, and Chico. She loved to go to clubs. I used to get phone calls from Fat Joe and his team, "Yo, your sister's here. She's trying to get in. Is it cool? I don't want to, like, let her in and you've got to worry about her."

I said, "Yeah, let her in, let her in." Because she would just go to the hottest parties and they would call me. If she didn't know the person to get in, they would just call me directly. Because, you know, she looks a little Hispanic and I'm Hispanic, so they would think, "Well, that's Will's sister." So that's how we connected back in Miami.

Then, I remember, one day I met with her at a bar. She was like, "What's wrong, Will? What's wrong?"

I said, "Well, you know, I'm going through a lot of shit." So I opened up to her. What sucks about dating someone who used to be a good friend is she knows all of your dirt, and she brought that shit back up when we got into it then. So I opened up my heart to her, and told her, "I'm going through this tax thing. I might go to jail. I'm losing my family. I'm far away from Paige. I might have to shut down the shop. I'm really fucked up right now." I was just in a really dark place.

And she was like, "Don't worry about it. Listen, you've got to go home. Don't worry about the shop, because you've got to go home and try to work that out with your wife. I know how much you love Paige. You've got to figure this all out." And she was very encouraging on that.

I said, "You know, you're right. I'm going to shut down the shop, and I'm really going to make a go for it, just see how it works out."

So I did that. I shut the Miami shop down and went home. Well, not really home, because Marilyn and I were separated; I was living out of a hotel. I found this little hotel in Riverhead, and they took good care of me

out there. I could wash my clothes, things like that. But I was sad and lonely. I recall spending a New Year's Eve alone in my hotel room, watching the ball drop on TV and thinking, *This sucks*. The following morning, on New Year's Day, I got the word that my dad had passed away. Talk about getting kicked when you're down. We went through the funeral process, and I said my goodbyes to Will Castro, Sr. I still miss him every day.

So I had the little hotel spot. I was living out there and going back and forth to Florida. Down in Florida, I reconnected with Sheila, and then, all of a sudden, one thing led to another. She asked me if I was still working it out at home.

I said, "Nah, we're going to go through a divorce. I'm not even living at home anymore." And we had our first kiss, and I said, "Wow. You know this is going to change everything, right? You know that this is a problem. This is not good. We're very, very good friends, and we're going to cross that line. We just did." I thought, *Nah, this ain't gonna work. I'm going back home. I'm going back to New York*. I said, "I don't need this right now."

So I went back to New York. But, to be honest, she just made me happy. She really did. She was so encouraging and so important to rebuilding me. It

was like crazy. So then we wanted to get an apartment together in Long Island City, while I was going through the house arrest. And she went with me, my mom, and my cousins PJ and Pete, to the sentencing.

And I knew right then and there that Sheila was a ride-or-die. And I gave her all my baggage. I told her, "I'm bankrupt. I've got no money, no business. I might be going to jail. I have tax fucking bills up my ass. I'm fucked up, and I have no car. Can I borrow your car? And I'm divorced, with a child. Do you still want to be with me?"

She said, "Yeah."

I said, "Fuck it. Let's rock."

So I told her dad and her mom, I said, "I'm telling you right now I am going through bankruptcy, divorce, IRS issues, you name it. I'm not a drug addict, though! But I have nothing to offer. Nothing. Just my love and my honesty. That's it. But I don't have anything." Her family took me in like their own. And, of course, when they did that, I said to myself, *I can't fuck this up*.

Somehow, things began to turn around. I don't know how God works, but I think this is a very key point: while I did my house arrest Sheila was holding me down. She was paying my bills, helping me pay my child support.

She was helping me out. She had a good job as a nurse and I was thinking, *Man, I can't be doing this. I feel like crap. I have no job. What am I going to do?*

Then I get a phone call one day, and it was this gentleman named Lance. This is why you've got to be cool to people, because you never know what's going to happen. This guy, Lance, had a magazine called *Street Trends*. It wasn't a huge publication. But he was a nice guy, and I could see that he was trying to build up this magazine. And I've been in all the big magazines; my clients were and still are getting big features, front covers, *Car Audio and Electronics*, *DUB Magazine*, *The Source, XXL*. Lance and his *Street Trends* was a small company—but I would always do things for small companies when they requested it, because that's how I started. I was a small guy. You've got to get an opportunity when you're building, just starting.

So Lance and his partner called me and said, "Will, can we get you as a feature? Can you get us maybe a celebrity or an athlete?"

I said, "You know what? I'm going to do it."

Later, they both called me again and said, "Hey, listen, Will, how you been? We've seen everything on the internet."

I said, "Man, I'm struggling, but I'm making things happen. I've still got my clientele. I'm still doing this."

He goes, "Well, I have an opportunity for you that you may like. They're a Wall Street company that just took over this car business that's going belly-up, but they have too much money invested. It's in Italy, and they need someone to get this car designed and built so they can have it at the Top Marques show in Monaco. Would you be interested?" I could not believe it.

Now, inside I'm saying, *I need this job. I'll start now.* But I had to play it cool, so I said, "I'm interested. I've just got to see what's going on." Because at the time, remember, I was under house arrest. I had to get permission to go out of the country.

They said to me, "Can you meet us at this restaurant called Rare 360 in Jericho, and we can sit down and let's talk about it?"

I said, "Sure." So I requested and was granted permission to go out to meet these Wall Street guys. And Lance, from *Street Trends* magazine. So we sat down, and I met a guy they called Mr. G, Mr. Govind. He's the owner of Soleil Motors. And it was him, and a partner named Paulson. And I learned that these gentlemen were starting a high-end, super luxury car

company. Not something that's easy to do. They were building an Italian supercar, the kind of vehicle that would be in the same class as McLaren, or Lamborghini.

So Mr. Govind asks me, "Would you be interested in going to Italy and helping us design this car?"

I said, "Yeah, of course." In my mind, I was thinking, *How am I going to get out of New York? I'm on probation*, and at the exact same time I was also thinking, *Man would I love to get out of New York for a while.*

Mr. Govind then said to me, "I've just got to run this by my son first."

So Mr. Govind called his son Adhar, and he said, "Hey, listen. We're sitting with Mr. Castro. We're thinking about hiring him to help design."

His son goes, "Hold on. Who?"

Govind says, "Will Castro."

The son says, "Will Castro from *Unique Whips*?"

Govind says, "Hold on. You had a show called *Unique Whips*?"

I said, "Yeah, I had a show, on Speed."

And he turned back to his son and said, "Yeah, the guy from the show."

His son said, "Dad, you better give him the job. I've been watching his show since I was a kid in college. Give him whatever he needs."

So Govind then looked at me and said, "My son said I better hire you because he used to watch you on TV, I don't know, in college."

I said, "All right. Well, let's make it happen."

"We'll get you some paperwork and let's get it done."

So I suddenly had a job! They gave me a great salary to design this car and travel the world. At first, I was scared. I didn't want them to know that I was under house arrest, but I needed to be honest. I said to them, "Listen, the only thing is I may have an issue going to Italy."

He said, "Well, that's a problem."

I said, "Yeah, I understand. I went through some tax issues, and they got me on a bracelet so I've got to get permission to get my passport. It's an issue, and I can't guarantee. I've got to talk to them first." So I came clean on it, and that's the first step in becoming a humble and honest person. I had to just say the truth, not knowing where it would go.

"I came clean, and that's the first step in becoming a humble and honest person."

He could have said, "No, it's just not going to work for us."

But Govind said, "Will, don't worry about it. Talk to your probation officer. If you need a letter, we'll get you a letter, and that's that." They got me the letter.

I went to see my probation officer, and he said, "No problem. I need a week's notice before you travel. You

WILL CUTTING HIS ANKLE MONITOR THE UPON COMPLETION OF HOME CONFINEMENT.

UNIQUE HUSTLE

go pick up your passport at the district, and you're good to go."

I said, "Man, America is great. They're letting me make money so I can pay them back, and I can still provide for my family, my child support." So a door closed with the shop in Miami closing down. Another one opened up where I could travel and see the world and design this Soleil car, which was a success. We got it to Top Marques twice, so I got to go to Monaco twice and bring Sheila. We went to Paris. Life was great.

You know, God is amazing. God was able to lift me up and bring me around the world, just on this Unique brand that I built, going from car detailing to car customizing. It's crazy when I really think about my journey.

And there was more in store for me. While I was working with Soleil Motors, I wound up getting a phone call from a cornerback with the New York Giants: Corey Webster, a guy with a Super Bowl ring. Corey wanted me to customize a truck for him. While we're doing the truck, Corey said to me, "Hey, Will, why don't you open up a new shop? I want to see you back on top." This is Corey Webster, a great person, great man.

I said, "Corey, I ain't got no money to open up a shop."

He goes, "Nah, I'm going to get it funded. Don't worry. I'm going to fund it out. Find a building, and we'll build a new Unique."

I said, "Okay. You sure?"

He goes, "Yeah."

I said, "Let's try it out for a year." And we created an interesting deal, I ran the business and was a part owner with Corey, but he owned the company. I licensed the Unique name to him.

We opened up a shop in New Jersey in 2012. We're doing all the Giants' cars. I was back in the game again! I had just taken a break for two years with the Unique thing, and I went right back into it in Jersey.

We were doing Busta Rhyme's Maybach, we're doing all sorts of cars, same business. We got some press in the *New York Post*, we did this, we did that, *boom*, we created a little buzz. Then one day I got an email from a television executive named Dave Lee at a network called Velocity. (By the time you read this, the name of the network will have changed to Motor Trend.) They're Discovery's 24/7 car channel. I knew Dave because before he worked for Velocity, he'd been an executive at Speed. Dave wrote to me, "Hey, Will, my boss, Bob Scanlon, and I see that you opened up a shop,

and you're doing your thing in Jersey. Would you be interested in talking about maybe doing TV again?" I was blown away. From ending the Spike show in 2010 to getting an email in 2012 from Velocity, I was thinking, *This is pretty cool.*

And I started talking with Velocity. Nothing happened right away because television development moves so slowly. Meanwhile, Corey Webster wound up getting cut by the Giants, and Corey was like, "Listen, you could take over the business. You've just got to pay me back."

I said, "Nah, let's shut this down, and I'm going back to Long Island." So that's what we did. I went back to Long Island and rented a place to house Unique that I called the Man Cave. It was around this time that I became reacquainted with a man who would become very important to the Unique story, Brian Kaminskey. Brian is the CEO of NEBR, the Northeastern Bus Rebuilders company. They repair city buses all over the New York tri-state area. It's a big company doing important work in the public transportation industry. They keep buses on the road. Anyway, Brian and I had first met ten years earlier, sometime after I had restored a tour bus for Swizz Beatz, who is married to Alicia Keys.

Unique Autosports, Holbrook, New York

Swizz called me and said he wanted to rent the bus out to other artists. Would I come and present the bus and all it was capable of to Kanye West and his team? Kanye was hitting the road to support his record, *The College Dropout*, and they needed a reliable, comfortable bus for the road. It was great to watch Swizz Beatz in sales mode, pitching the beauties of the bus to Kanye and his entourage. They rented the vehicle. Unfortunately, someone brought a driver in from out of state who did not know the New York roads well and on the Southern State Parkway, this new driver took the bus under the wrong underpass and opened up the roof like a sardine tin. I received a frantic call from Swizz telling me I had to find someone to fix this bus *quick*, Kanye's tour was starting.

To be honest, I was in over my head. I didn't know anyone in the bus body industry. But I called my contact, Audrey, at Albert Kemperle auto body supply on Long Island, and they sent me to Brian Kaminskey at NEBR to do the work. I'll never forget my phone call with Brian because he turned me down; he thought the timeline was too quick. I was not used to being told no. Here I was, working with some of the biggest names in entertainment, in this case Swizz Beatz and Kanye West. We all expected results, and none of us were

EXTERIOR AND INTERIOR OF SWIZZ BEATZ'S BUS

guys to take no for an answer. But Brian very calmly explained to me that there was no way he could get the bus done on time and he hoped that somewhere down the road we could find a way to work together. So I took the bus to another place in New Jersey, Kanye finally got on the road, and I forgot about Brian for a long while. But we reconnected again ten years later in 2014, at a Christmas party thrown by Bobby Hotaling for his insurance business. Suddenly Brian and I found ourselves face to face at this year-end celebration. Brian was interested in the Unique brand and, seeing me get back on top, he offered to be a sponsor as I got back on television. It was a great deal for me because he was offering me a turn-key body shop and paint booth for the work. I also had plans to launch the new series by redesigning Busta Rhymes' tour bus and having Brian's big facility was going to help me get it done. Another of the many projects Brain and I were able to work on together was designing a corvette that was auctioned off and raised over $250,000 to support the Federal Law Enforcement Officers Association, that benefited the families of fallen law enforcement officers.

I met with Dave Lee at SEMA that year, and he said, "We're ready."

I said to Dave, "Okay, I want to do it. You're going to have to come to Long Island and see me in this place I'm renting that I call the Man Cave." The Man Cave was a small facility in Smithtown that I turned into a makeshift garage. I have to tell you, I saw the enormity of the opportunity, but I was also nervous. I'd had an adversarial relationship with my last production company, and *Unique Whips* did not do me any favors when projecting my image on the TV screen; I'm sure the Feds at the IRS watched that show! So it was important to me to come at any new production from a humble place of stability and strength.

Dave Lee at Velocity said to me, "We're going to introduce you to an executive producer, a guy named Mark Finkelpearl. He's done a lot of car shows, and we think you'll get along. We think he's a good producer for you." So I went to meet Mark in Manhattan for lunch at an Italian restaurant in Midtown and we hit it off. He understood me and who I was, where I was coming from, where I had been. We had different backgrounds, but I could tell Mark shared my vision for building Unique back to the company it was before all my troubles. And then some. Mark was truly supportive of me, not just for getting television done. Then I remembered what Dave Trombley had told me about

surrounding myself with great people. From Dave to Mark and all the people they brought with them, this Velocity team was built of great people. Together, we started developing *Unique Rides*, my best television series ever. The *Unique Rides* first season went very well. Busta was involved. And many people from my old crew came back—Buju, Erick, Chico, and my second in command, Jimmy Bibbee. It felt like we were headed in a positive, new direction. It was strong.

But the yo-yo is always snapping up and down, and, at the end of the first season, Mark and his people left the production company after a new upper management team arrived. Suddenly, I felt unmoored again, rocking in the waves and stormy seas. Mark and I hit it off and we all worked really hard to deliver six great episodes in the first season, and now he was suddenly gone. By this time, Brian Kaminskey had become more than just a sponsor; he was a mentor and close friend of mine, and I would always ask him for advice.

Sheila was pregnant at this time with our second child. Our first one, Will, Jr., was born in 2013 and by this time he was nearly three years old. Will was another shining light, a new start for me in parenthood with a woman whom I adored. But the second pregnancy did not go as smoothly as the first. Sheila began noticing that the

baby did not move around inside her the way that Will had. She had that mother's intuition that something wasn't going right. The doctors agreed, and, at seven months, two months shy of a full-term pregnancy, they ordered a C-section. Wes Castro was born in July of 2016. He got a W name like his dad and brother because, in my mind, it also stands for Winner. And my boys are Winners! Still, the eerie silence in the delivery room was deafening. Something was wrong. Wes, Sheila, and I were all separated after we left the delivery room. I was in the dark for a long while about exactly what was happening. When I finally did get to see Wes, he had tubes all over him, and monitors covering his body. I felt horrible, and, of course, Sheila was distraught as any mom would be. But we soon learned what a fighter he was. Wes has those Lower East Side genes in him! He has the grit and the determination, the hustle to make it in New York and on this planet. Wes was diagnosed with something called Prader-Willi Syndrome. It's a genetic disorder that can happen when you are missing certain genes. There is no cure for it, but it can be treated. Kids who suffer from it experience bad things that you'd never wish upon anyone's child: trouble eating, delayed development in areas both physical and cognitive, weight gain,

WILL AND CARMELO ANTHONY WITH HIS UNIQUE JEEP

sleeping disorders. It's not good. This made season two of Unique Rides very difficult, balancing personal obligations and network obligations. I will admit when the camera stop rolling, it was visible. I remember just like it was yesterday filming the reveal of Nick Cannon's Chevelle. After we had filmed a couple of scenes, Nick pulled me to the side and asked what was going on. I explained Wes' situation and that my mind was spinning, not really knowing what was going on. I had just been told that Wes was being transferred to St. Mary's Children's hospital in Queens. Nick said "Will I know Wes will be great." He mentioned that he was on the board of the hospital and immediately began making calls to hospital executives. I was shocked to be honest I knew Nick was multi-talented but I had no idea he was on the board of this hospital. What a small world. Nick was right, Wes couldn't have been in a better place. I can't ever express how grateful Sheila and I are for the great care Wes received from the entire of St. Mary's Children's Hospital. Sheila and I also will never be able to thank Nick enough for all that he did and always checking in on Wes and his progress. But, as I write this, Wes is more than two years old now, and he's doing great; he really is. We'll have a lifetime of managing his Prader-Willi, but we also have a beautiful

and darling son and brother. If you've bought this book, you've done your part, because I am donating a portion of the proceeds from it to Prader-Willi research.

WILL AND NICK ON THE SET OF UNIQUE RIDES

As the old cliché goes, the show must go on, and Velocity wanted a second season of *Unique Rides*. We carried on with a new executive producer, replacing Mark, and I did the best I could to forge ahead. Ultimately, we had eighteen episodes filled with the kind of stars I'd been working with for years, including some new faces. I got to work on cars for

Odell Beckham, Jr., Austin Mahone, Kid Chocolate, John Leguizamo, Mario Lopez, Don Omar, Geraldo Rivera, Billy Joel, Jason DeRulo, Carmelo Anthony, Nick Cannon, and many others. As always, I'm humbled and grateful. As the song by Robert Earl Keen goes, "the road goes on forever and the party never ends."

THE LONG YELLOW LINE

"I'm going to keep flying down the road."

Some people enter the second half of their lives, and they get a chance to sit back on the porch and take a long and satisfying look at what they've accomplished and all that they've built. That's not me. Maybe it's because I'm a guy from the projects of the Lower East Side. Maybe it's because of my run-in with the government and how long it took me to get things right. Perhaps it's because I have a second family and young children as I finish this book. Maybe it's because it's become harder and harder to make it in America these days, to grab the brass ring and hold on so tight that you never lose it. Or it's all of that. And I think the truth also is it's just how I'm built: it's my constitution. In many ways, I'm still the paper boy on the corner selling as many *Post*s as I can. I'm still that guy hustling the valet lot at Mario's or detailing cars in a one-stall garage. I'm always striving for more. My own unique hustle won't quit. There's an old saying in the music business, "In this line of work no one retires." If you look around, it's true. Across the music business, people in every genre (not only hip-hop) are still out there, giving it

their all into their sixties and beyond. I'm like them. I'm going to keep doing what I do, working with the most inspiring people in sports and entertainment as long as they will let me design their cars. I'm going to keep flying down the road, looking for the end of that long yellow line. I'm grateful and happy with the fact that I may never actually find it. If I'm lucky. And I am lucky. I'm also blessed and humbled. God is great.

ACKNOWLEDGMENTS

Will Castro: I wish to acknowledge God for all His blessings. My mother, for bringing me into this world. Will Castro, Sr., for giving me his name and the street smarts and hustle that it takes to make it. My Papi, Bonfacio Martinez, who taught me respect and how to take care of my family. He's my guardian angel. Thanks to my siblings, Bobby, Chris, Nayree, and Dawn. They've always been there for me when I've been down and out. To all of my many nieces and nephews. Thanks to my other family, the Afzalis, for all they have done. Thanks and love to my children: my daughter Paige and my sons, Will and Wes. Thanks to all of my friends who have been there through the good times and the bad— you know who you are. Thank you to all of my Unique clientele. They are my customers first, but they are also my Unique family. Thanks to our sponsors; there are too many to name, but you have made Unique what it is today. Thank you to each and every one of our fans. Thank you to my Team Unique. I also want to say a special thank you to Mark Finkelpearl for believing in me and helping me bring this book to reality. Last but not least, thanks to my rock and my soulmate, Sheila.

Mark Finkelpearl wishes to gratefully acknowledge and thank Brenda Knight and Maura Teitelbaum. Heartfelt thanks and gratitude to Shaan Akbar, Josh Beck, Roger Henry, David Lee, Peter Neal, Rita Pathak, Debbie Parpovitch, Bob Scanlon, Michael Sobel, Sam Wackerle, Chase Ward, Alex Wellen, and the entire gang at Motor Trend, Motor Trend On Demand, and Discovery, Inc. Thank you and deep respect to Bob Burt, Ray Carballada, Steve Cheskin, David Evans, Phil Fairclough, Brad Fanshaw, Laura Farina, Jonathon Fishman, John Ford, Billy F Gibbons, Jon Dee Graham, Steve Grecsek, Mike Greenberg, Lori LaPorte, Adam Leibner, Jennie Malloy, Chris Masterson, Erik Nelson, Brandi Page, Austin Raywood, Geraldo Rivera, Laura Scalzo, Sam Shon, Don Sikorski, Nate Starck, Steve Tannen, Tim Vincent, Eleanor Whitmore, Brian Woyt, and Ron Yerxa. All my love to Max Finkelpearl, Talia Zitner, and Zoe Zitner. Undying thanks and love to Rue Zitner. At least we're enjoying the ride.

ABOUT THE AUTHORS

The founder of Unique Autosports and Unique Designs, **Will Castro** is the star and producer of Velocity Network's *Unique Rides*. Previously, he starred on and produced Speed's *Unique Whips*, *Unique Whips Special Edition*, and *Unique South* that aired on Spike TV and Fox Sports. Will's podcast, *Unique Radio*, is distributed by Apple, Player FM, Spotify, and others. Will began his career in the automotive industry more than thirty years ago. Transforming each vehicle he touches into a rolling work of art, Will has become the go-to customizer for professional athletes, hip-hop sensations, and pop music stars. He's worked on upwards of twenty-five hundred cars, ranging from everyday drives like Toyotas to the most expensive European exotics like Rolls-Royce, Ferrari, McLaren, and Lamborghini. Will Castro is from the Lower East Side of Manhattan and lives on Long Island.

Mark Finkelpearl is an executive producer whose long career in non-fiction television has afforded him a shotgun seat on some of TV's premiere car programs. While on staff at Discovery, Inc., he was the production executive in charge of such series as *American Chopper*

starring the Teutul family, *American Hotrod* starring the late legend Boyd Coddington, *Overhaulin'* and *Rides* starring Chip Foose, *Wrecks to Riches* starring Barry White, and *The Kustomizer* starring Vini "Big Daddy" Bergeman. Finkelpearl created *Car Czar* starring Alan Lewenthal for Nat Geo. He worked with the late great George Barris, designer of the original television Batmobile and KITT from *Knight Rider*. He served as executive producer on the first season of Will Castro's *Unique Rides* for Velocity. His latest car shows include *Hand Built Hot Rods* starring design titan and multiple SEMA award winner, Steve Strope, and *Fastest Cars in the Dirty South* about a team of grudge racers in Muscle Shoals, Alabama. He lives in Washington, DC.

UNIQUE LIFE SCRAPBOOK

WILL AND
BOBBY CASTRO

WILL'S 190e SITTING ON 20" CHROME HAMMERS

XIBIT + WILL
FIRST 2 ORGINALLY CAR PIMPS CHILLIN BACK
STAGE UP IN SMOKE TOUR IN CHI -TOWN

ME AND EM TOOK THIS PIC IN DETROIT IN HIS OFFICE

JERMAINE WIGGINS + WILL IN 2002 NEW ORLEANS
SUPERBOWL AFTER PARTY

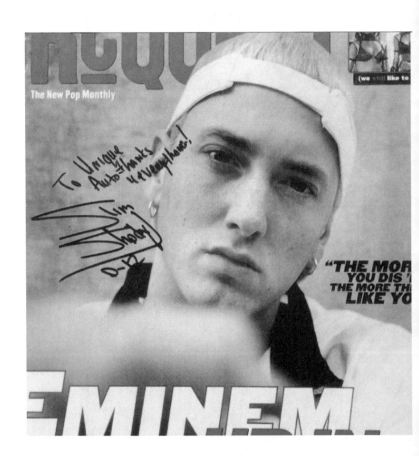

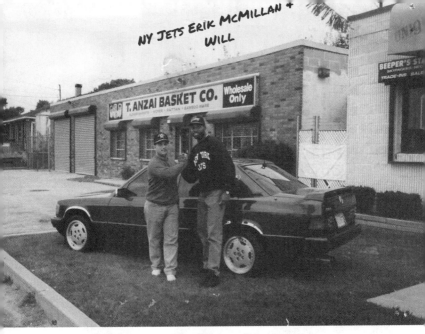

NY Jets Erik McMillan + Will

Busta with his "Sunset" Lambo

BUSTA and SwissBeatz Westside Highway, NYC

BUSTA + WILL NYE 2010 Shore Club Miami

**Fat Joe 2004 at Unique Holbrook, NY
with Rolls Royce Phantom**

Chip Foose

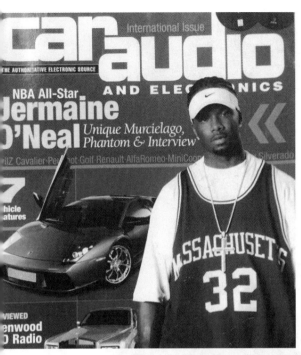

NAS
+
NICKI MINAJ

QUEENS, NY

CHICO, WILL, & REME

WILL & SHEILA 2012 IN LONG ISLAND CITY, NY

At 99 Jamz in Miami 2009

Nicki and Will in Miami 2009

WILL & JEFF GORDON

WILL & MARK FINKELPEARL

WILL + NAS ON THE PRODUCTION SET OF UNIQUE RIDES

BENARD HOPKINS WITH TITLE BELTS AND HIS UNIQUE RIDE

ICE T + COCO

WILL CASTRO SR, WILL, AND CHRIS ON NEW YEARS EVE, LES

WILL, HIS MOM, AND BOBBY IN BRENTWOOD, NY 1985

WILL, HIS MOM, AND BOBBY IN CLEARWATER, FL, 2015

9/19